Peace

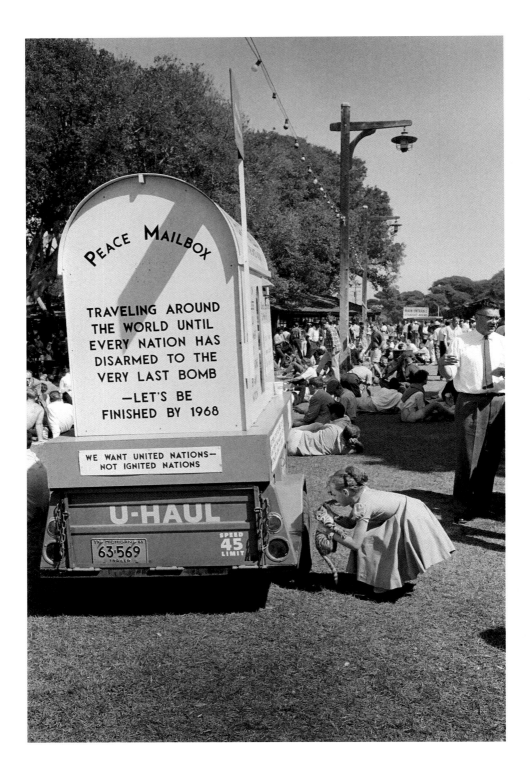

Peace

PHOTOGRAPHS BY JIM MARSHALL

REEL ART PRESS

Get

e to start w

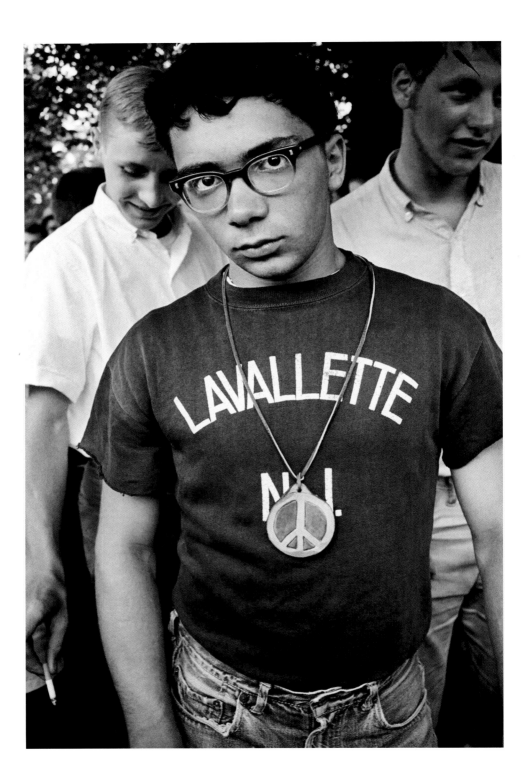

PHOTOGRAPHS
JIM MARSHALL

FOREWORD
SHEPARD FAIREY

INTRODUCTION
PETER DOGGETT

AFTERWORD
JOAN BAEZ

EDITED BY
AMELIA DAVIS
TONY NOURMAND

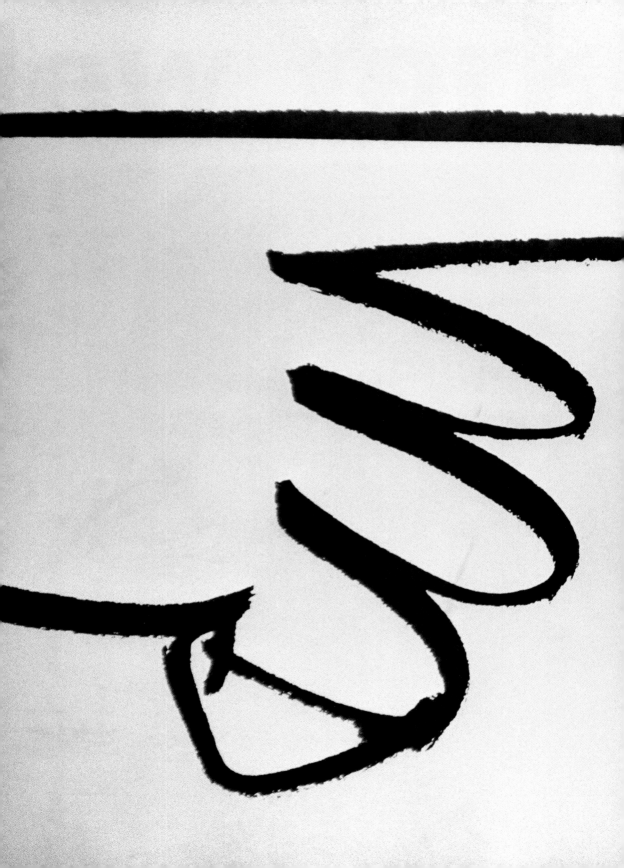

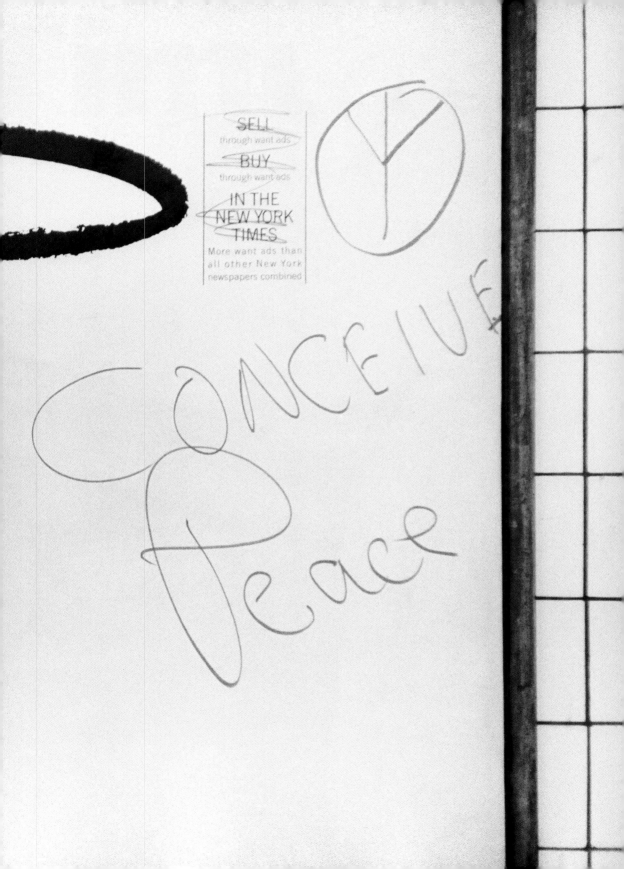

SELL
through want ads

BUY
through want ads

IN THE
NEW YORK
TIMES

More want ads than
all other New York
newspapers combined

CONCEIVE
Peace

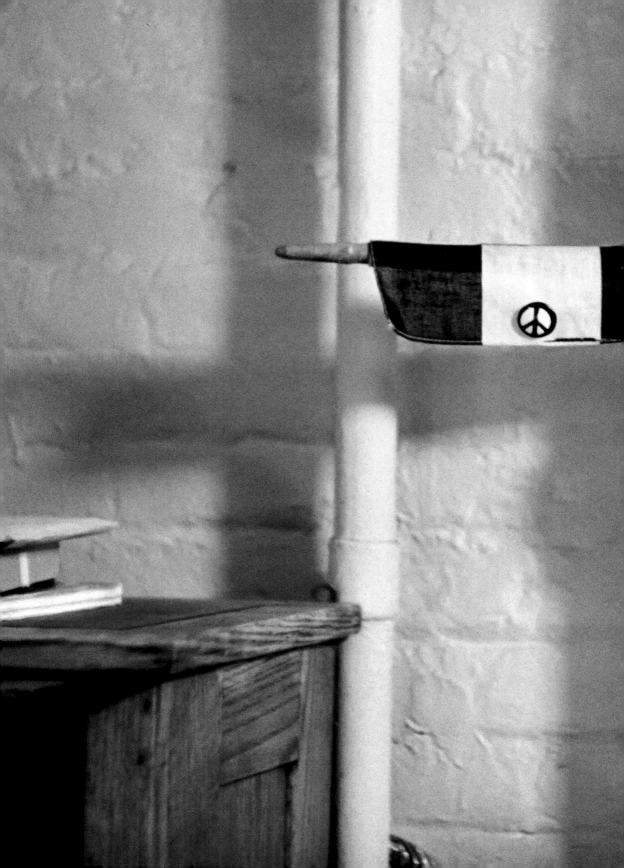

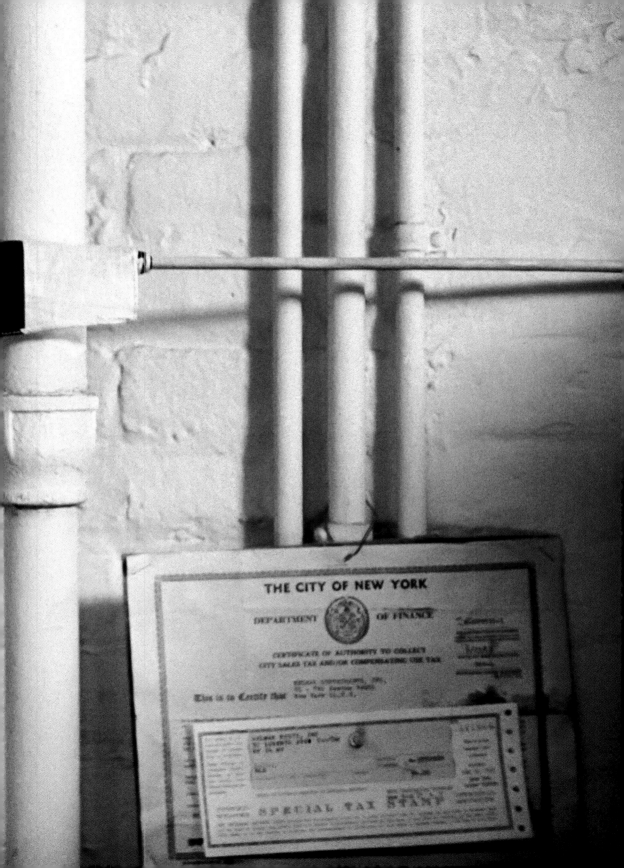

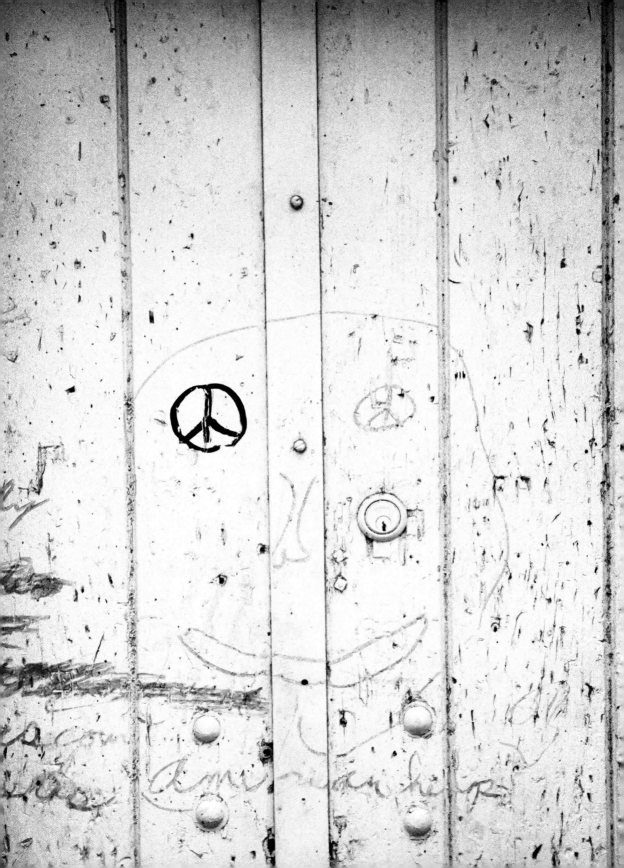

SOMETHING'S HAPPENING OUT THERE

The peace sign has long been an important image and symbol for me, not just because I am pro-harmony and anti-war, but because it is the graphic icon that taught me the power of an easily recognized and reproduced symbol. As a rebellious teen in the 1980s, I embraced the peace sign as an emblem of counter-culture favored by skateboarders who listened to punk and reggae. Looking back, it is remarkable that the peace sign crossed over to punks who said "never trust a hippie!" Even the "reject everything" punks were susceptible to the graphic strength and allure of the peace sign. I was one of those punks and not only did the peace sign pique my interest visually, but it also led me to investigate anti-war ideas and movements. I eventually ended up putting a *Stop The Arms Race Not The Human Race* bumper sticker on the family station wagon, most likely as a domino effect catalyzed by a curiosity about the peace sign. Eventually, I had a professor, a hippie I trusted, who taught me about the Vietnam War, the anti-nuclear proliferation movement, and the protest movement against the Vietnam War in the late 1960s and early '70s. My teacher was cool enough to mention the role symbols like the peace sign, the dove and flowers in the ends of guns played in the activist movement and how especially the peace sign became pervasively woven into many areas of pop-culture. In many ways, I think that the peace sign as an easily understood ubiquitous symbol of opposition to the Vietnam War played a major role in diminishing the public support for the war.

When I began to create images protesting the war in Iraq, I immediately thought of the success of the peace sign during the Vietnam era, and I began incorporating the symbol into many pieces of my work. Not only do I think the peace sign is strong visually, but it also brings to mind an activist movement whose energy and tactics created a widespread shift in the culture. In the post 9/11 climate of fear and the rush to war with Iraq, I saw many parallels

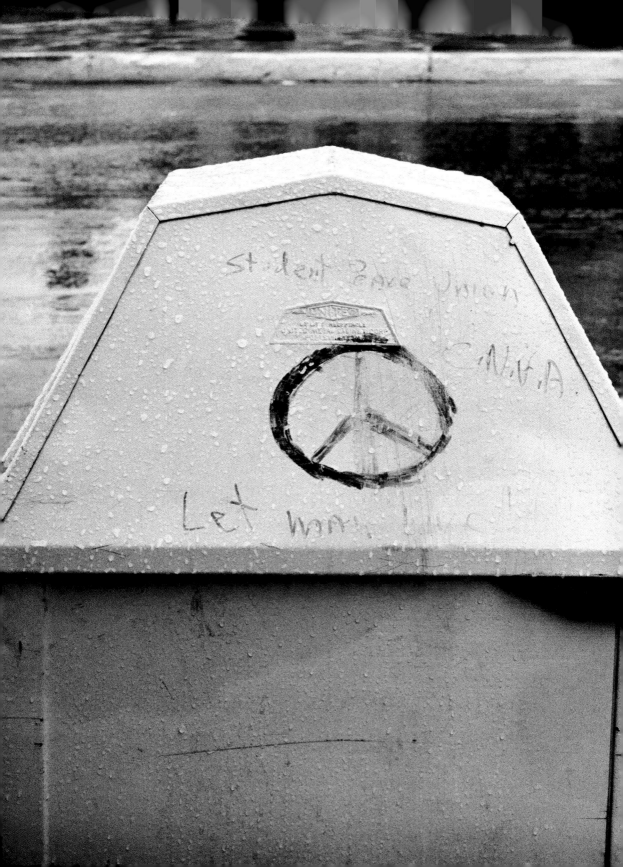

to the Vietnam era which inspired me to use the peace sign as a pacifist symbol, but also to remind people just how analogous the mistakes of Vietnam were to the mistakes in Iraq.

Looking at the images in Jim Marshall's *Peace* book I'm struck by how acutely Marshall picked up on the rise of the peace sign as a counter-culture, and later a dominant-culture, symbol. Jim has an image from 1963 (we can tell from the date on an ad poster) with a peace sign drawn on a subway wall. Many of Marshall's photos are of graffiti of the peace sign with "ban the bomb" written next to it. Marshall was obviously attuned to the peace sign as part of the anti-nuclear proliferation movement long before it reached a critical mass as a symbol of the anti-Vietnam War movement. These photos demonstrate Marshall's keen eye for imagery signifying the counter-culture and his awareness of the viral and do-it-yourself nature of the graffitied and hand-made peace signs showing up on walls, guitar cases, and clothing. What I find most exciting and unusual about these peace photographs is that symbols and slogans of peace dominated by the peace sign are the subjects of these portraits. They showcase an idea rather than pictures of famous musicians, scenesters, or politicians, and the artful nature of the images indicate that Marshall saw the role of the peace sign as a crucial character or protagonist within the culture. I'm most moved by the mystery and anonymity of the images that only show the peace sign and maybe accompanying text as the visible residue of an act of defiance. Small rebellious acts like a piece of graffiti pushing back against injustice encourage me to take action and remind me that regardless of how alone I may feel, there are kindred spirits out there. I think Jim Marshall saw the value in documenting the evidence that something's happening out there!

SHEPARD FAIREY

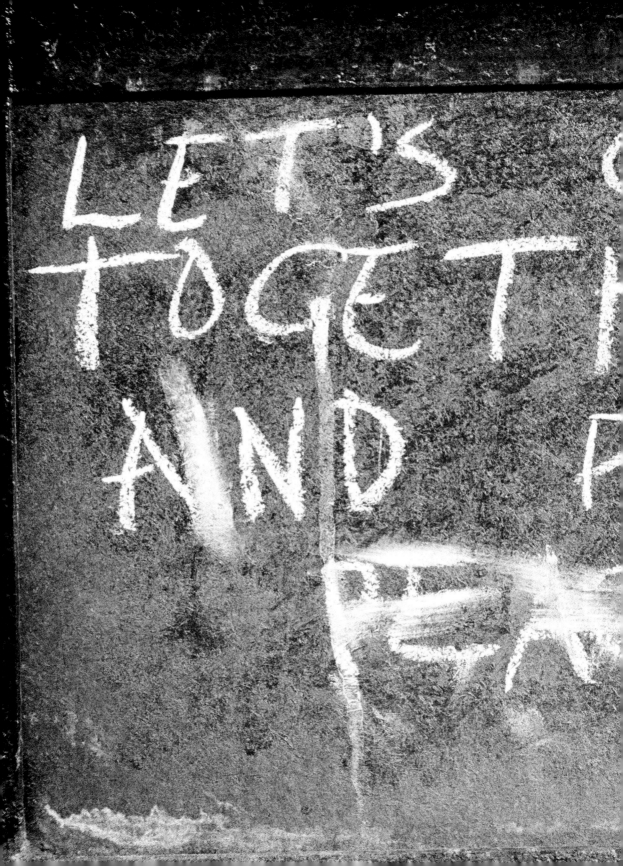

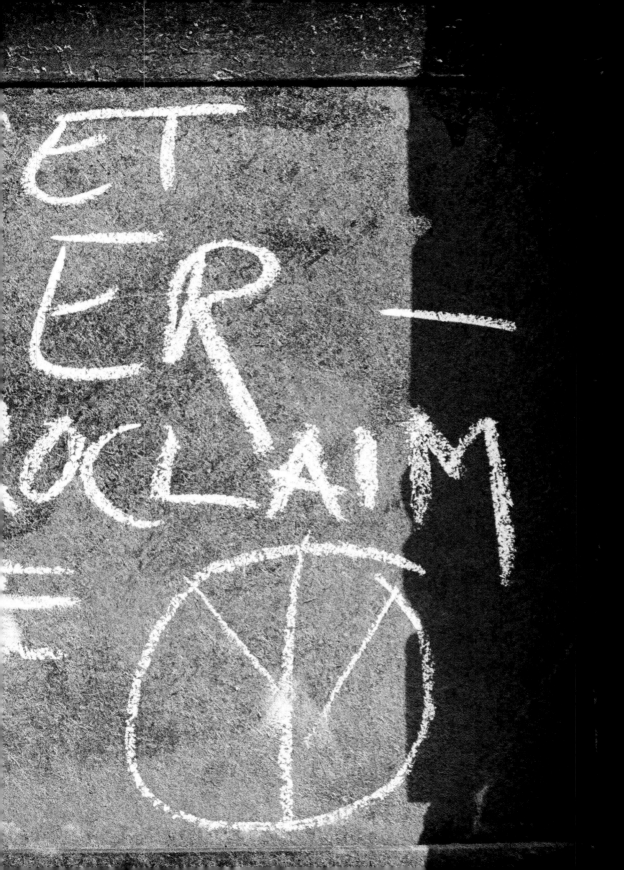

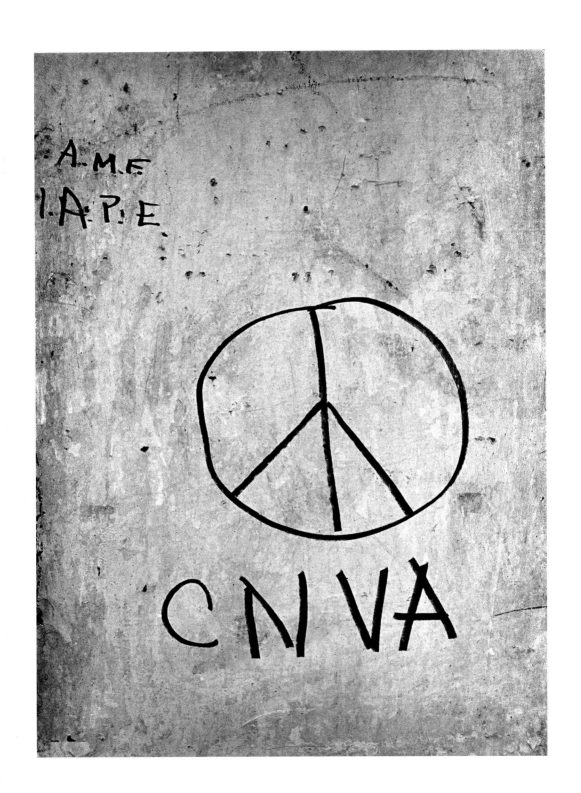

PEACE SYMBOL IN ACTION

Gerald Holtom's peace symbol was and still is today the instantly recognisable motif of the British anti-nuclear movement, the Campaign for Nuclear Disarmament. In America, meanwhile, it was adopted by the CNVA—the Committee for Non-Violent Action. This organization was founded in New York City, to consolidate protests against the testing of nuclear weapons. In 1962, they staged a two-month march from Nashville to Washington DC, to demonstrate their disgust at America's commitment to nuclear arms.

By 1965, the CNVA had widened its horizons, and joined forces with those who were crusading against the war in Vietnam, such as the Vietnam Day Committee. A similar journey was undertaken by the group Women Strike for Peace, whose slogan, "Peace is the Only Shelter", is pictured in one of Jim Marshall's photographs in this collection. In other shots, Marshall documented how campaigns and their organizations could collide—the peace sign being partially covered by a 1963 sticker protesting against the architectural ugliness of New York, for example, or painted across a vending machine for the Communist Party newspaper, *People's World*.

Later in the decade, the peace symbol proved to be as potent an emblem as the humble flower when it came to expressing the naive but heartfelt utopianism of the hippie movement. Yet in many ways the most poignant photograph in Marshall's collection depicts the Peace Mailbox he discovered at the Newport Jazz Festival in 1961. "Let's be finished by 1968", the Mailbox states plaintively; but America's involvement in Vietnam would not reach its ignominious conclusion for almost another decade.

PEACE

8-10-12

BA
MDZ

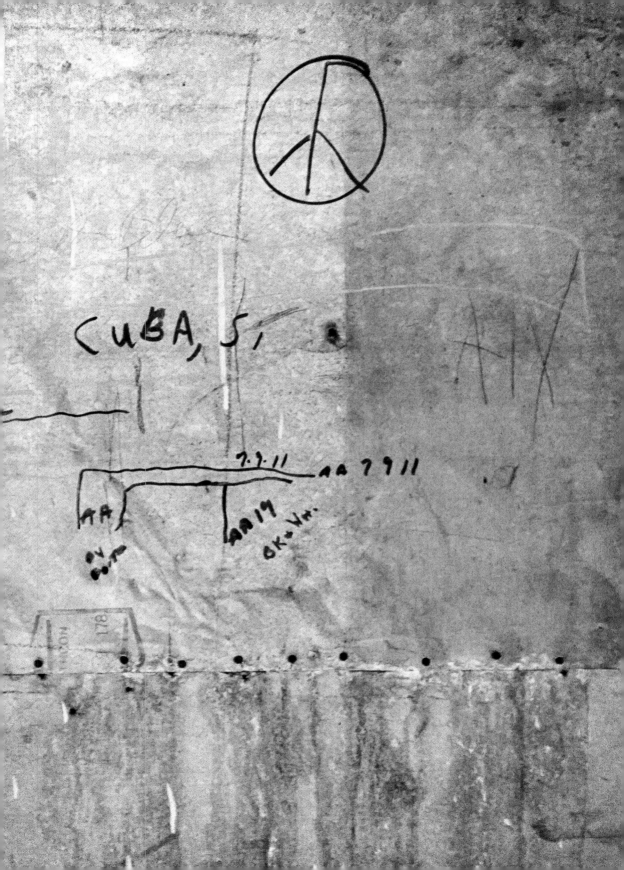

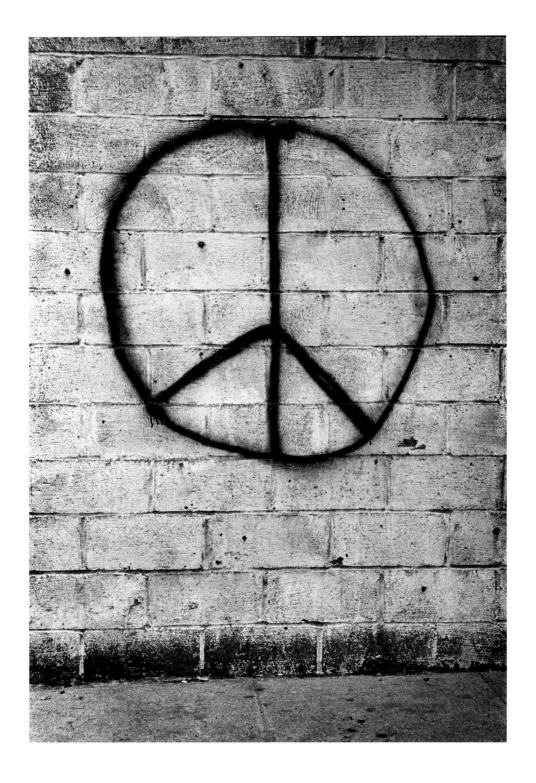

INTRODUCTION

It was the simplest of icons: two semaphore signals combined within a bare circle. Devised as an emblem for a single political protest, it escaped its original purpose and crossed campaigns and continents. Throughout the 1960s, the peace symbol acted as both a rallying point and a code, scattered across the decade like the post-horns that identify an underground network in Thomas Pynchon's 1966 novel, *The Crying of Lot 49*. It was a beacon of belonging; of shared goals and ideals; of utopian optimism amidst political turmoil.

So deeply had the peace symbol embedded itself in 1960s counter-culture, and so widely was it used, that far-right activists systematically set out to defuse its power, and denigrate its origins. In July 1968, the small-circulation magazine *Free Enterprise* claimed that, far from embodying the spirit of peace, the symbol denoted the ultimate of evil: "the Broken Cross of the Anti-Christ". This was proof, the article asserted, of the Communistic intentions of anyone who employed this symbol. Though these allegations were eventually debunked, they are still being repeated today in right-wing evangelical propaganda.

The truth was more prosaic, and more pure. The symbol was the invention of Gerald Holtom, a Christian pacifist. He was a member of a small British group, the Direct Action Committee, one of many which sprang up in the late 1950s in an effort to combat the proliferation of nuclear weapons. The Committee was planning a protest march at Easter 1958 from London's Trafalgar Square to the Atomic Weapons Establishment at Aldermaston, and the newly formed CND (Campaign for Nuclear Disarmament) pledged its support. An artist and designer, Holtom was asked by CND to invent a motif that would represent the protest, and its supporters, to the outside world. His first suggestion—the Christian cross inside a circle—was rejected as being too closely linked to a single faith. Instead, he reached back to the international language of flag semaphore, and combined the signals for "N" and "D", to connote Nuclear Disarmament. "It was ridiculous at first," he admitted many years later, "such a puny thing." But the symbol was printed on 500 lollipop-shaped signs which were carried aloft by marchers, while others held square cards bearing the same design against their chests, or sported lapel badges.

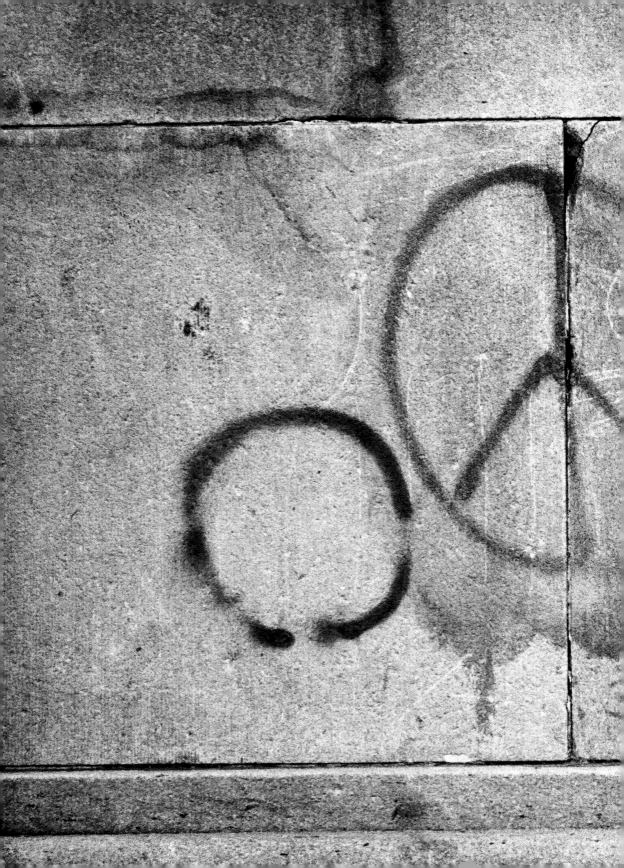

Holtom's design received a slightly baffled reception; the *Manchester Guardian* recognised only "a sort of formalised white butterfly". In keeping with the message of the Easter festival, the marchers' signs employed a black symbol against a white background (to suggest the death of Christ) on Good Friday; and then white against green on Easter Sunday, to mark the resurrection. But subsequent protests retained the "classic" black version of the symbol.

Within a matter of months, Holtom's peace symbol had been carried into a Pacific nuclear testing zone by the American pacifist Albert Bigelow, whose boat the *Golden Rule* proudly displayed the emblem. By 1960, it had begun to appear at American anti-nuclear demonstrations, incorporated into the protest material of the CNVA (Committee for Non-Violent Action). Then, as the obscenity of the conflict in Vietnam became clear to students and campaigners across America, both the CNVA and the peace symbol were refocused on this decade-wide struggle. Thereafter the motif was impossible to contain: without ever losing its political potency, the symbol was soon an all-purpose signifier of peace, love and unity among the hippie movement. It could be worn as a tie-die decoration or a tattoo; spray-painted or scrawled amidst flower-power imagery or on city walls. (As a small child in the mid-60s, my introduction to the peace symbol was seeing it scratched into the ancient monoliths of the Stonehenge monument, an act of both desecration and daring counter-cultural defiance.)

No wonder, then, that early in its adoption as an emblem of anti-nuclear sentiment in America, it should capture and hold the attention of photographer Jim Marshall. He recognised its cultural significance, and was intrigued by the symbol's ability to morph between causes, and evade strict definition. Regardless of the ostensible subject of his photographic assignments, he documented the symbol's appearance on subway walls and street posters, on political banners and in hippie collages. At one moment, it might be the central motif of a protest march or campus demonstration; at another, it acted almost as a secret code for those with the same political leanings. As these pages illustrate, it could be found at jazz or folk festivals; in urban squalor or festive display; linking anti-war and anti-nuclear campaigners with those who simply refused to belong to LBJ's "Great Society".

The juxtaposition of photographs in this book reflect the breadth of Jim Marshall's interest, the keenness of his eye, and the way in which diverse cultural strands merged into one turbulent landscape in the America of the

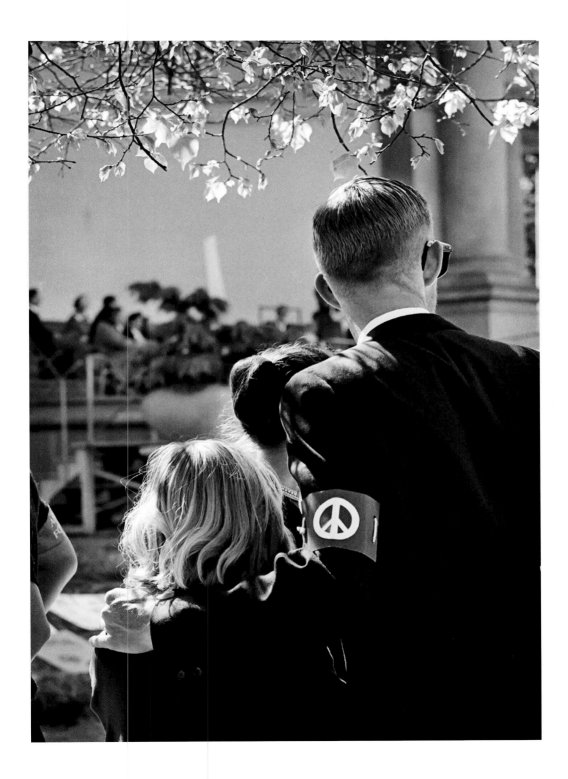

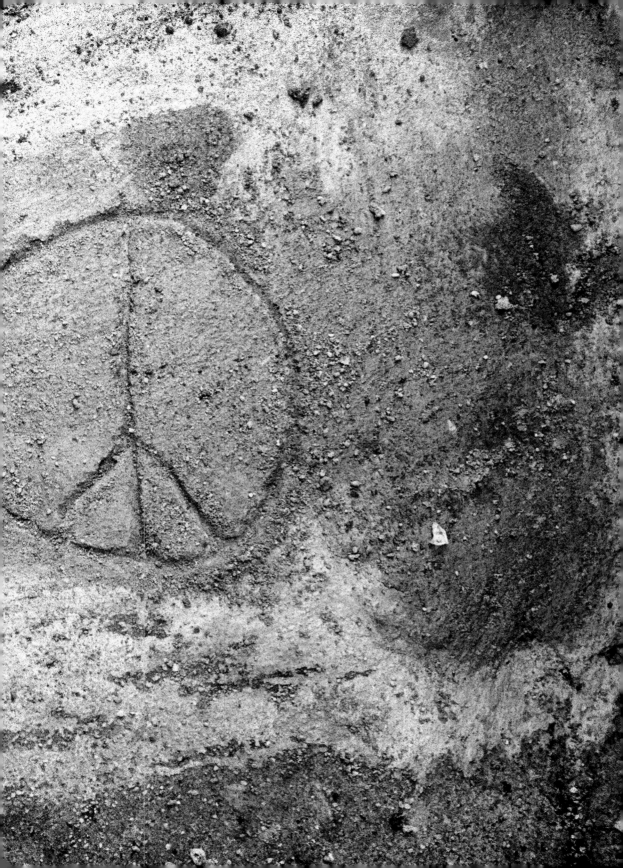

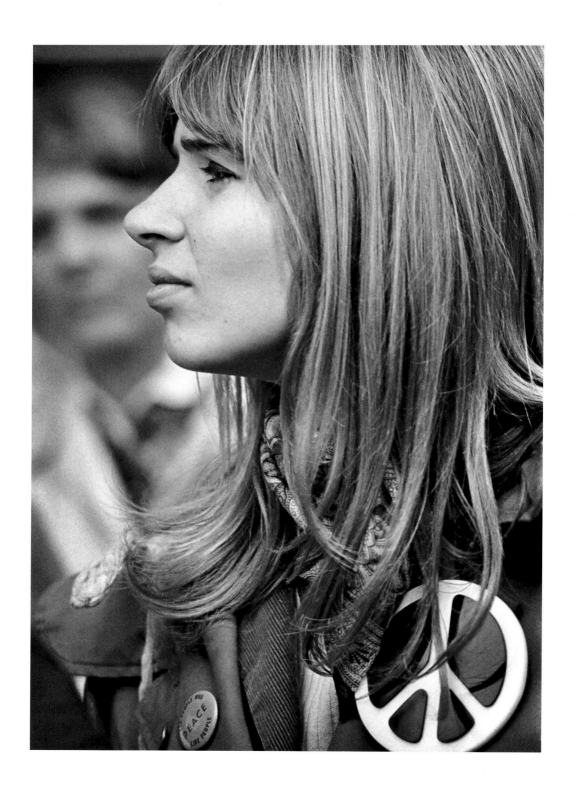

1960s. Amelia Davis, herself an award-winning photographer, worked closely with Marshall, and now curates and controls his archive. "He had immense curiosity," she recalls. "You can see it in his contact sheets. He was always looking beyond. Another photographer who was on assignment to shoot the Newport Folk Festival would have concentrated solely on that task. But Jim always had his eyes open, to see what else was happening around him." She compares his contact sheets to a writer's notebooks: an opportunity to see the fertile mind of an artist in the art of creation.

Under Marshall's gaze fell legendary musicians such as Ray Charles and Bob Dylan; homeless refugees from 1960s consumerism; and, never far from hand, the peace symbol, and those who carried it with pride. "Jim is still under-appreciated as a photo-journalist," Amelia Davis says. "His philosophy was that he was a historian with a camera. His success as a photographer of jazz and rock 'n' roll musicians means people always assume that was the only thing he did. But he was a master of his art. It astonishes me that he took these photographs using a completely manual Leica. That was a difficult camera to use, and yet he was brilliant at capturing a moment in time —whether that was a live performance, or simply something he saw on the streets or in the subway." The *Peace* project is a testament to his vision and his technical genius; and also a vivid evocation of a symbol, and a sensibility, that survived the turmoil of a remarkable decade.

The social and political advances that resulted from that decade, hard-won by those who took to the streets with banners and peace symbols aloft, seemed to be set in stone. For those who participated, it must have seemed impossible that the campaigns against militarism, imperialist adventurism, racism, sexual discrimination and the madness of nuclear proliferation would ever have to be fought again. But in these increasingly unsettled and alarming times, all the old certainties are under question and threat. Even the ultimate horror of a nuclear apocalypse is once again shadowing our world, while freedoms that have been accepted as natural for decades are being overturned and undermined.

Once again, it is time to speak truth to power; to stand up and be counted against prejudice and injustice; to challenge authoritarianism; to choose peace and love over war and hate. Jim Marshall's photographs do not merely capture a momentous era in our collective history: they demonstrate what needs to be done, and what can be done, to ensure freedom for ourselves and those who follow us. As the sticker on the guitar case says: "Peace is the only shelter".

PETER DOGGETT

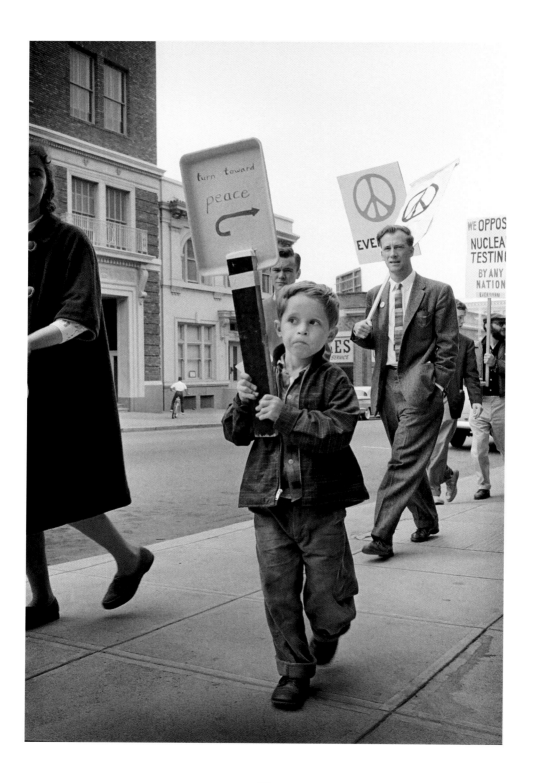

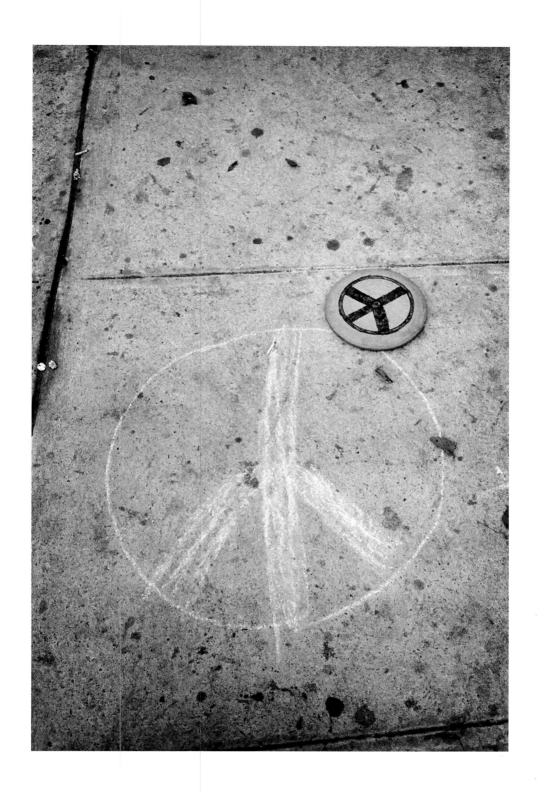

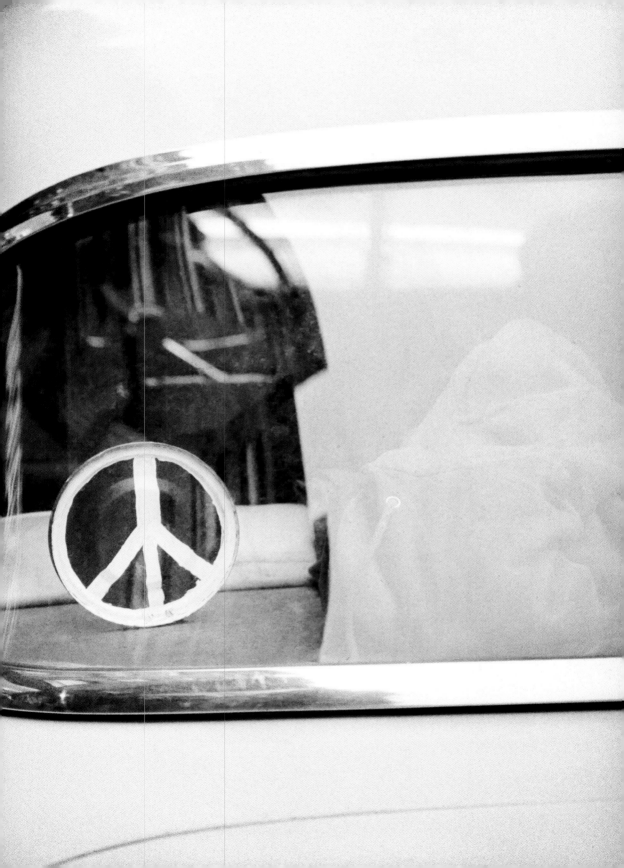

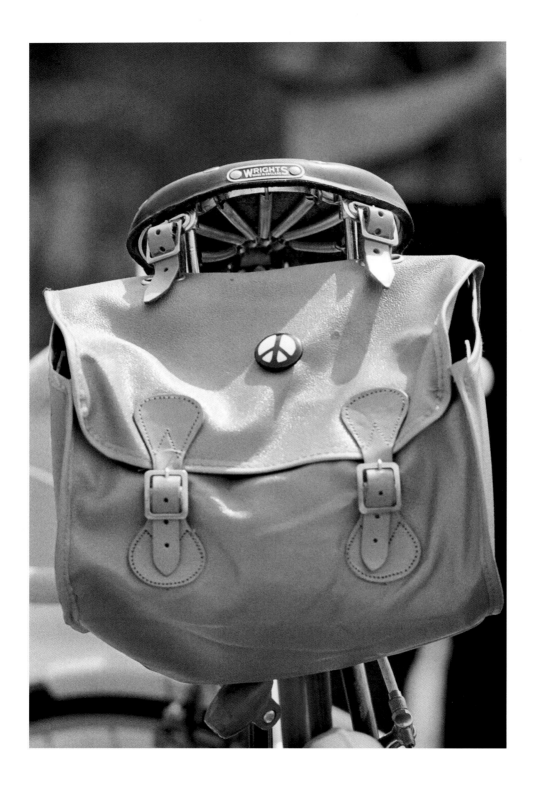

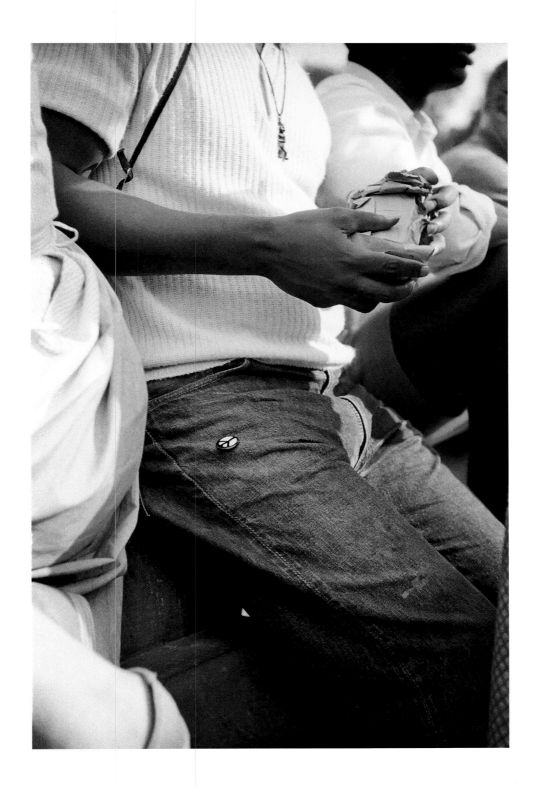

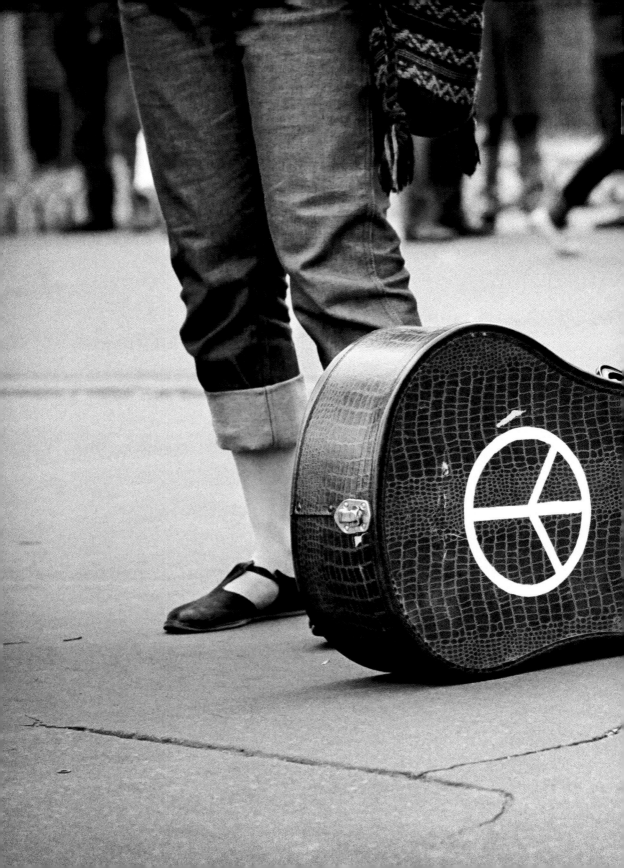

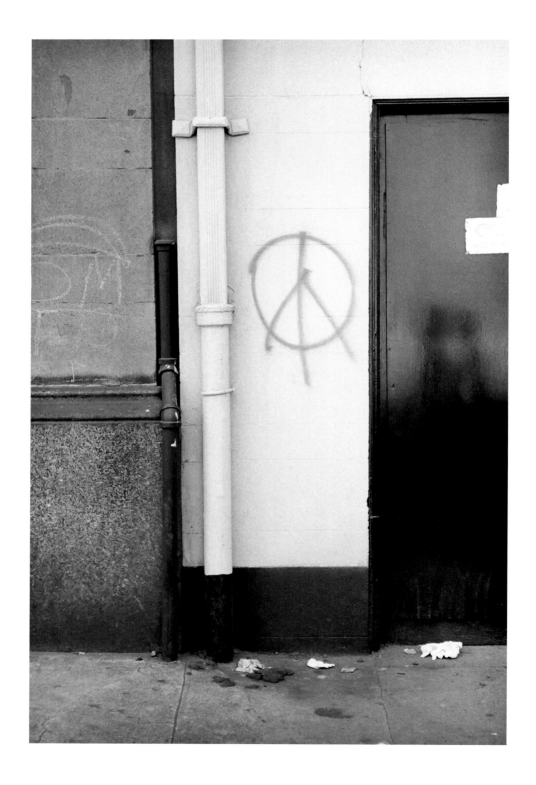

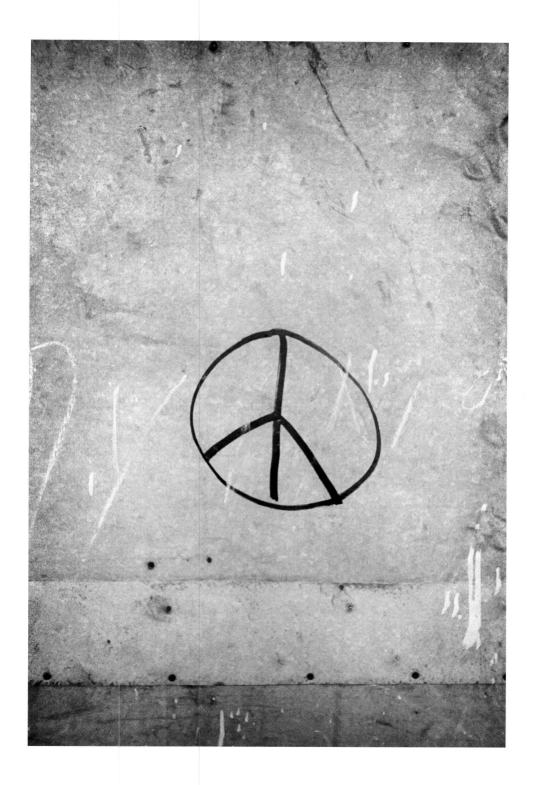

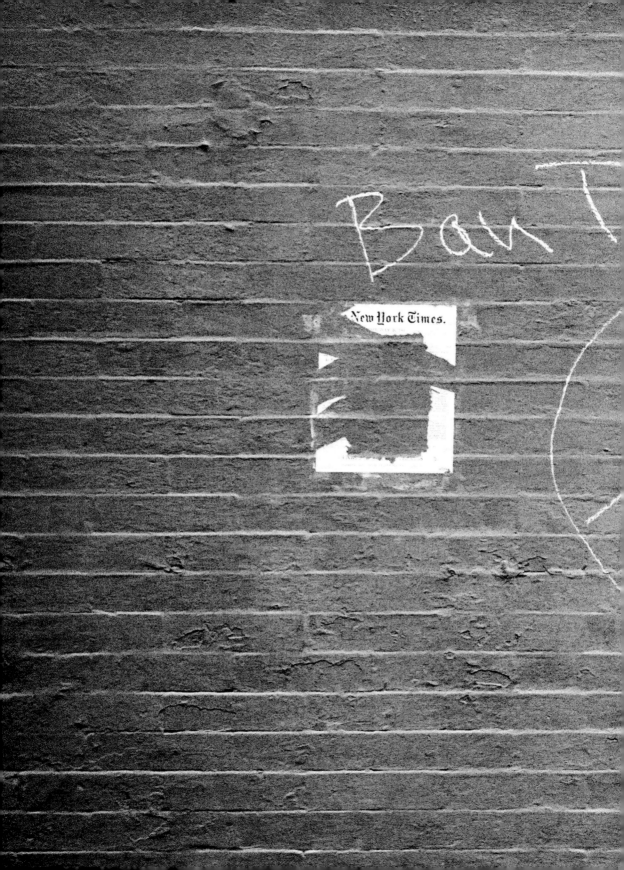

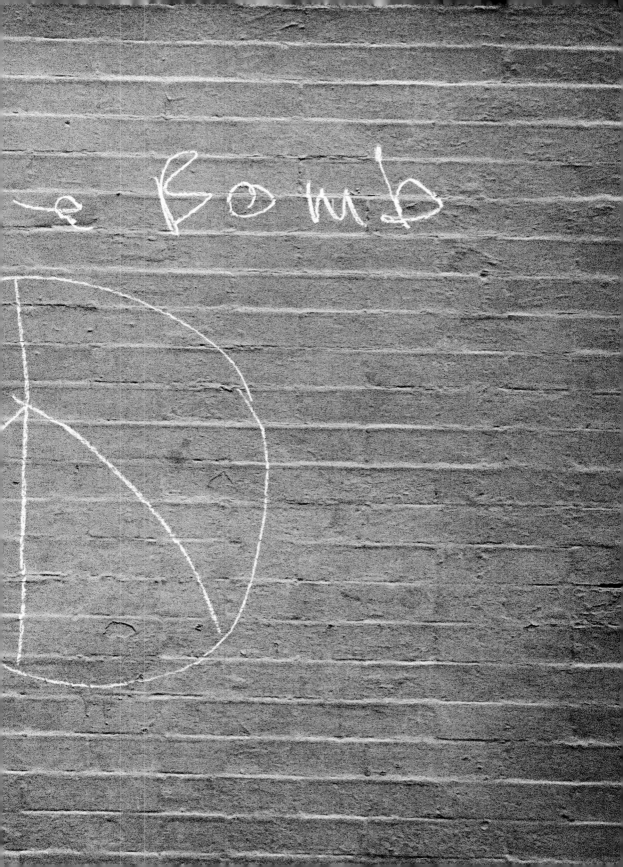

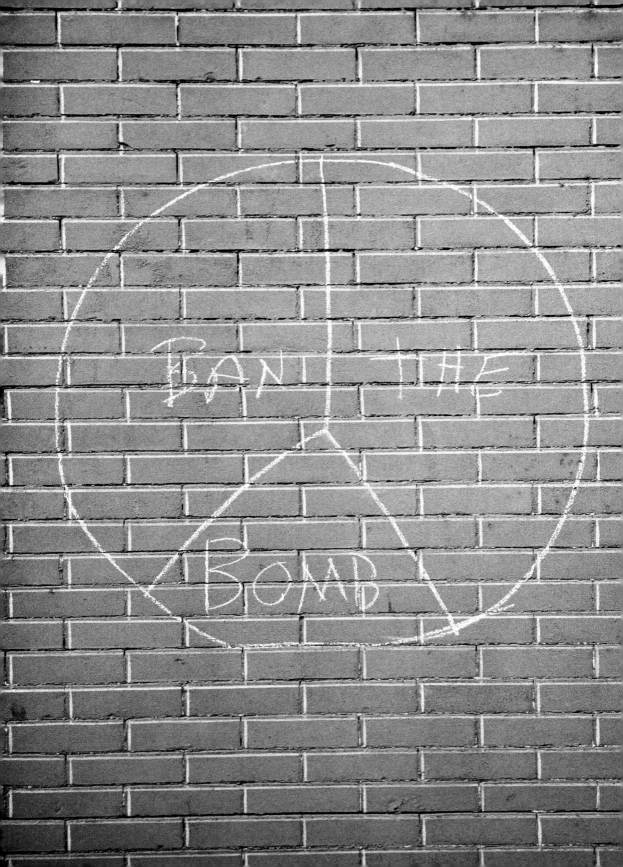

BAN
The
BOMB

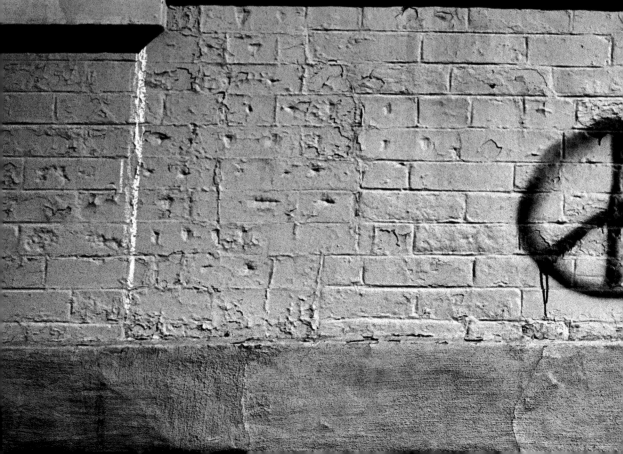

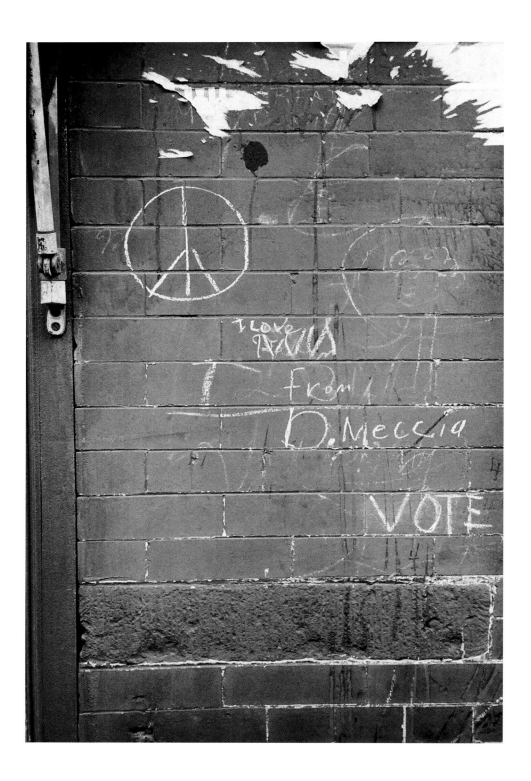

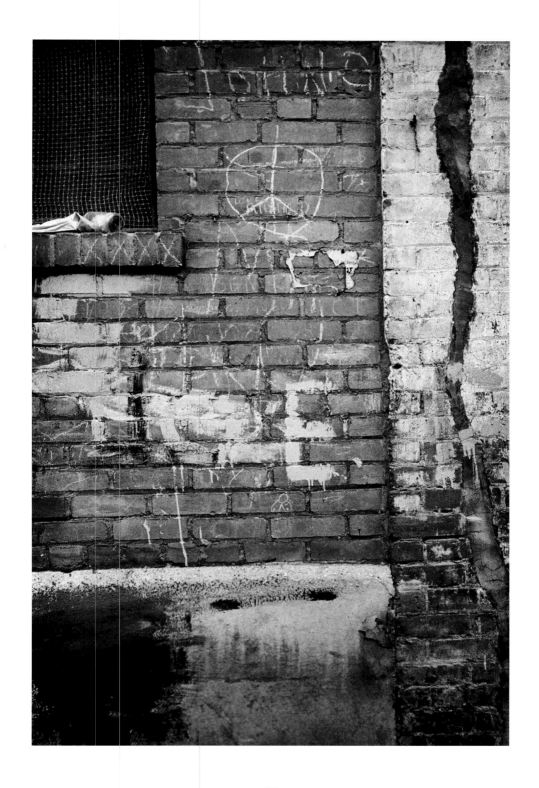

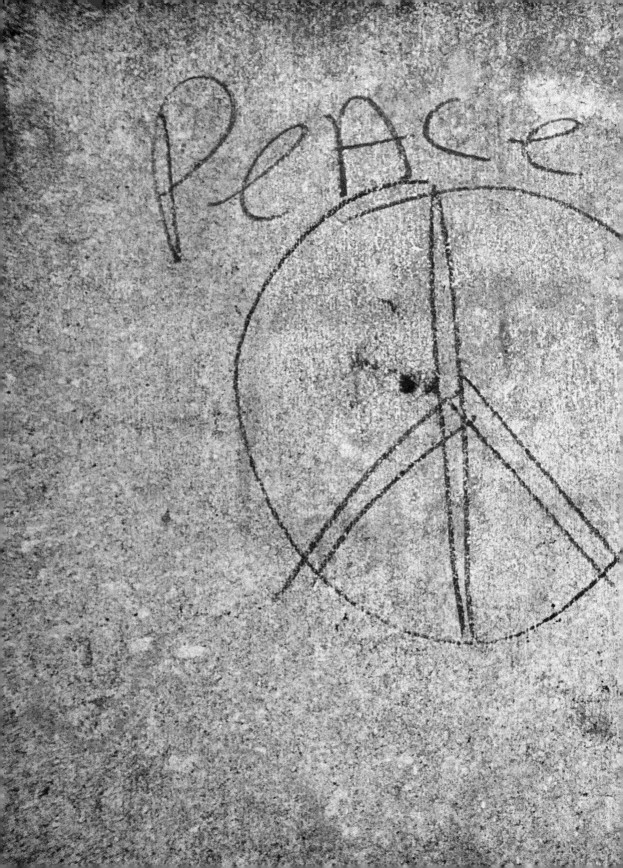

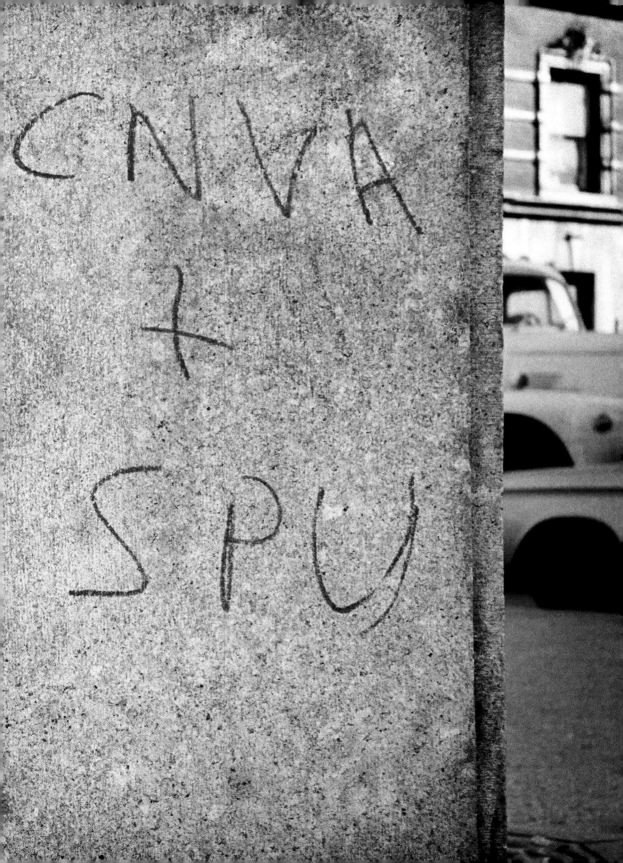

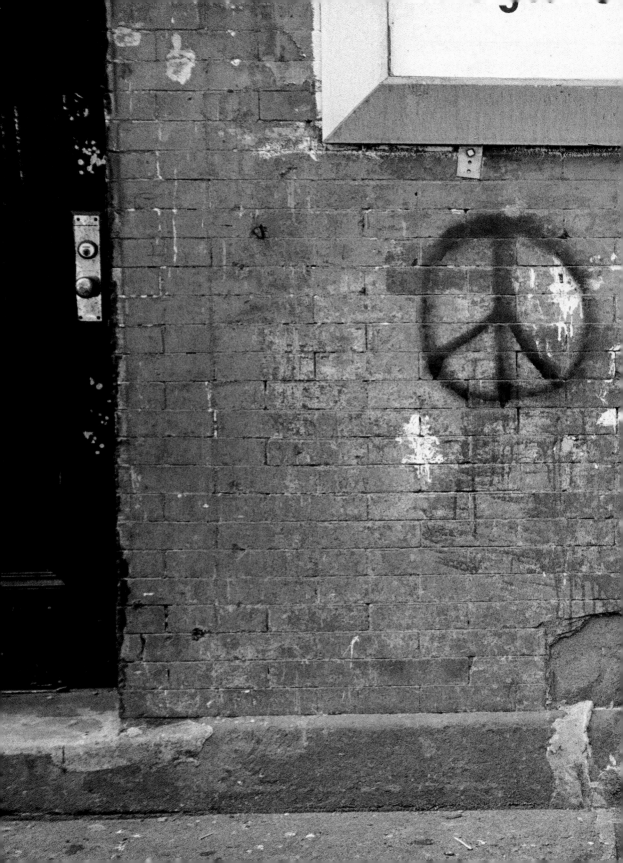

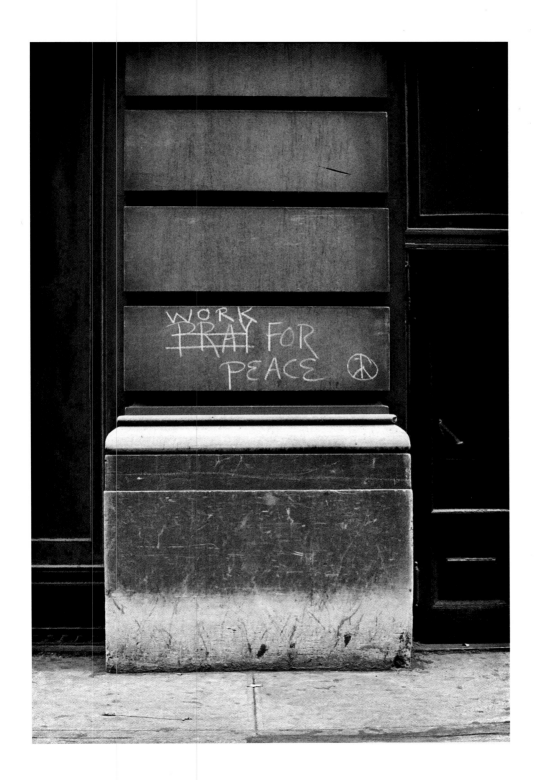

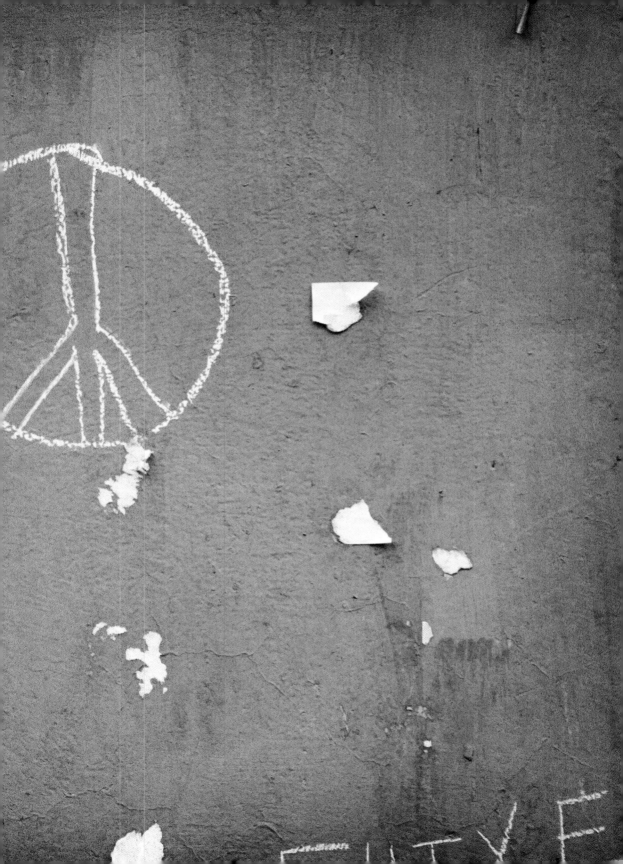

Canadian Club

Admiral
TELEVISION
APPLIANCES

Castro

MAIL B

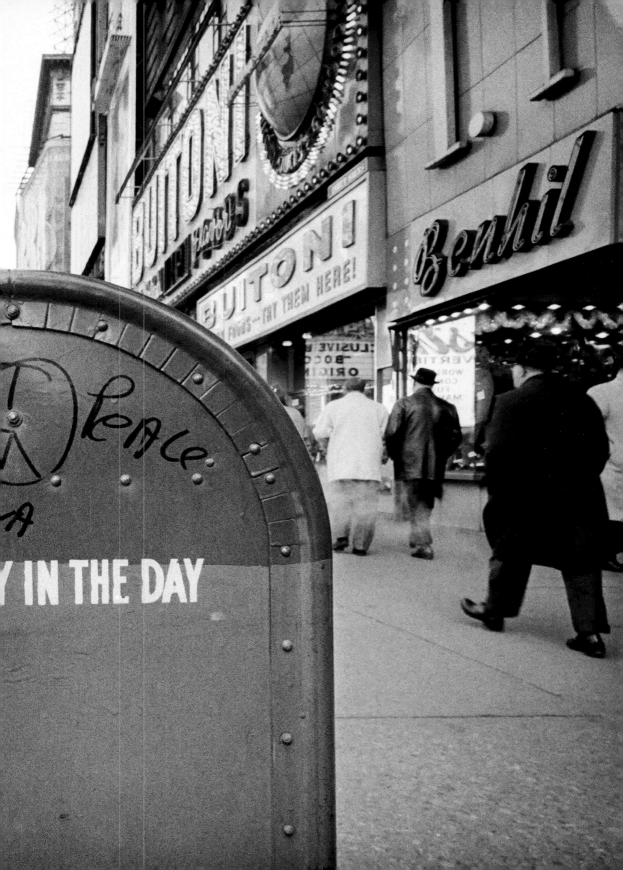

Ban The
Narcotics
Squad

While you're at it Ban
The Bomb

Take oblivion

BAN THE BAN
BAN YOURSELF
FROM THE VILLAGE

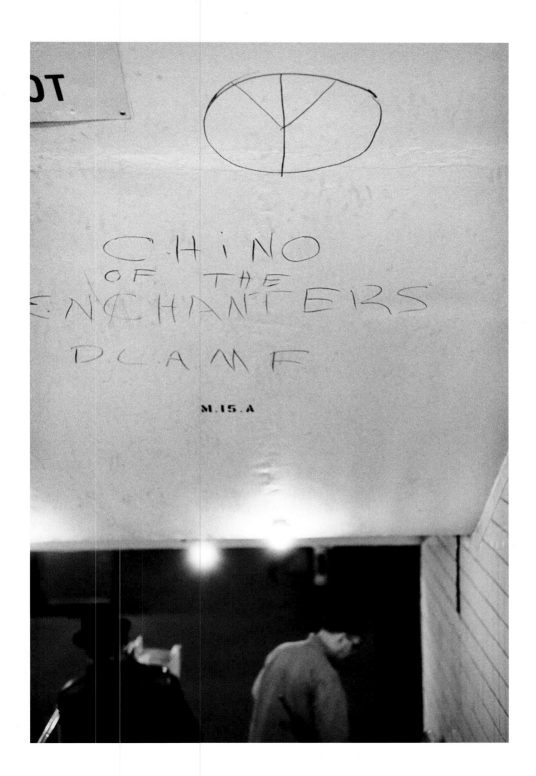

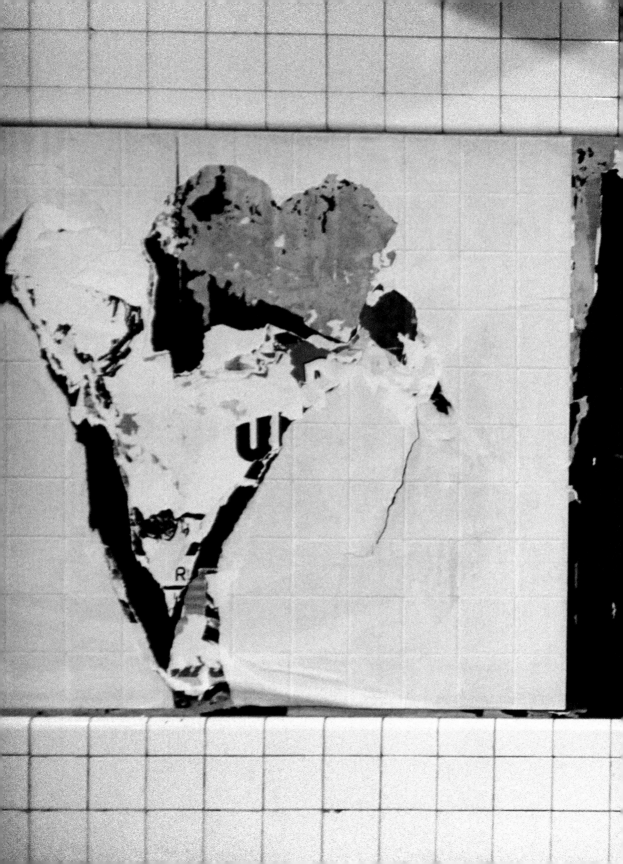

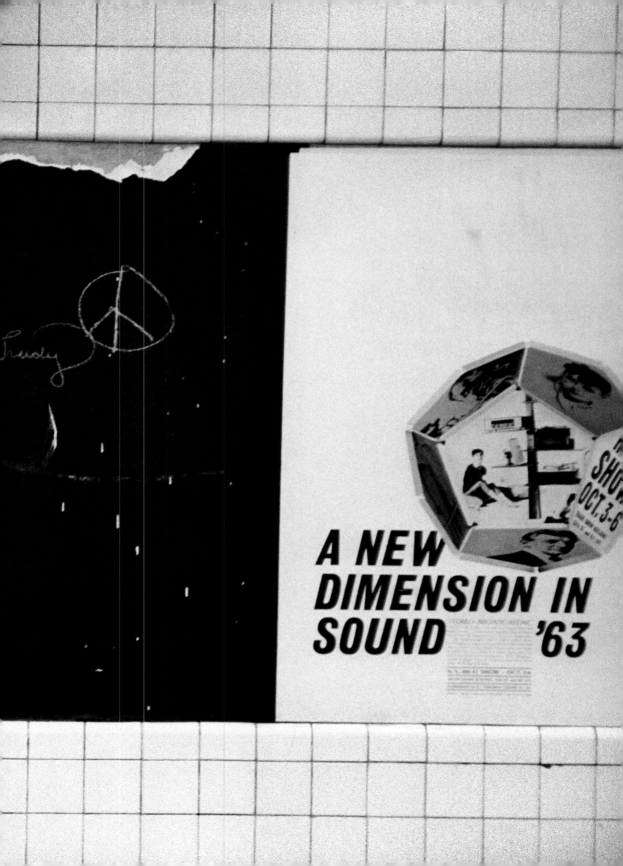

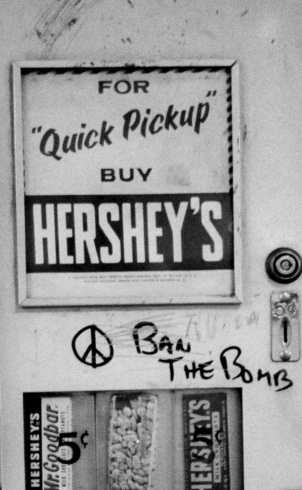

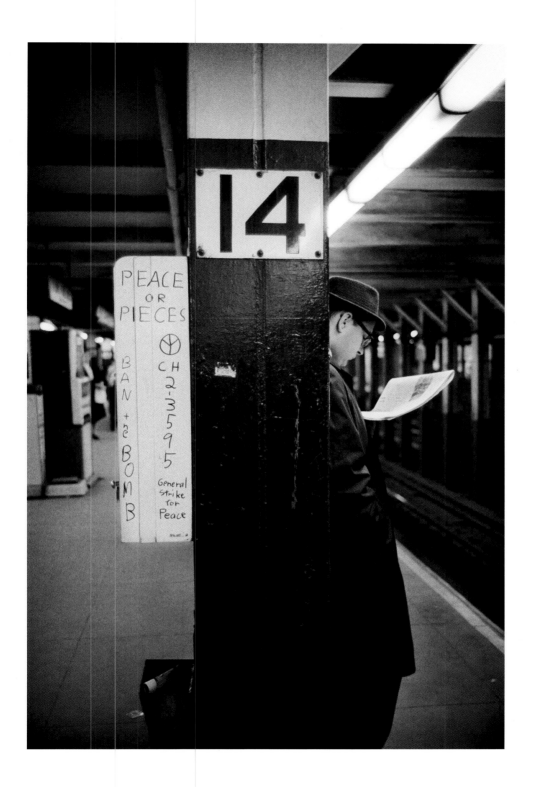

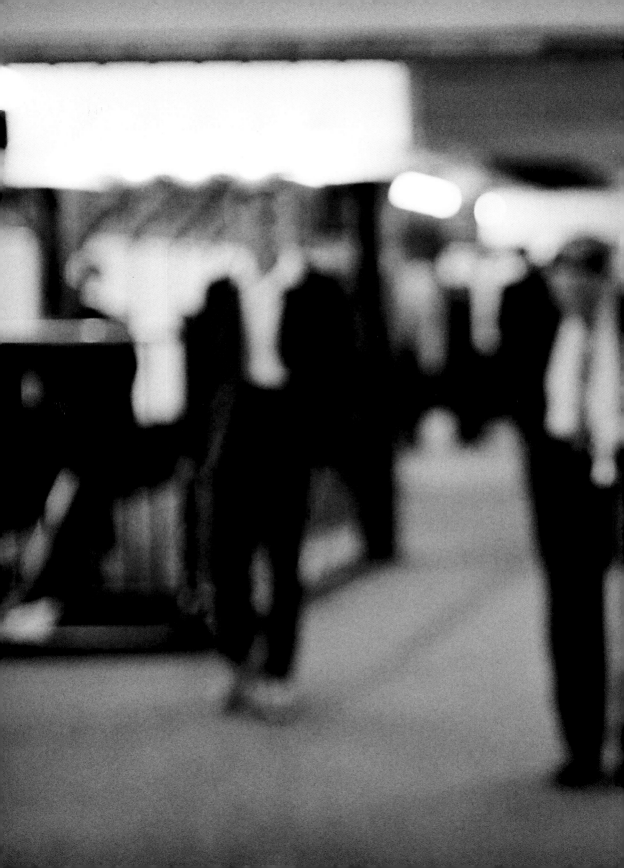

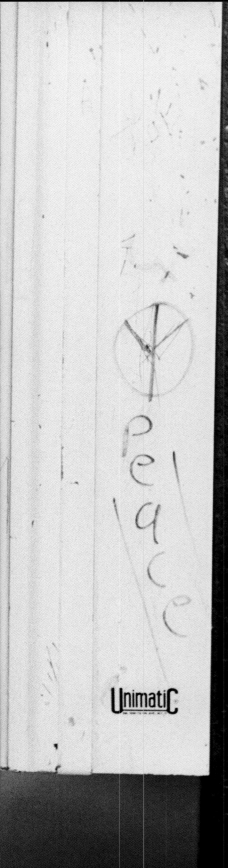

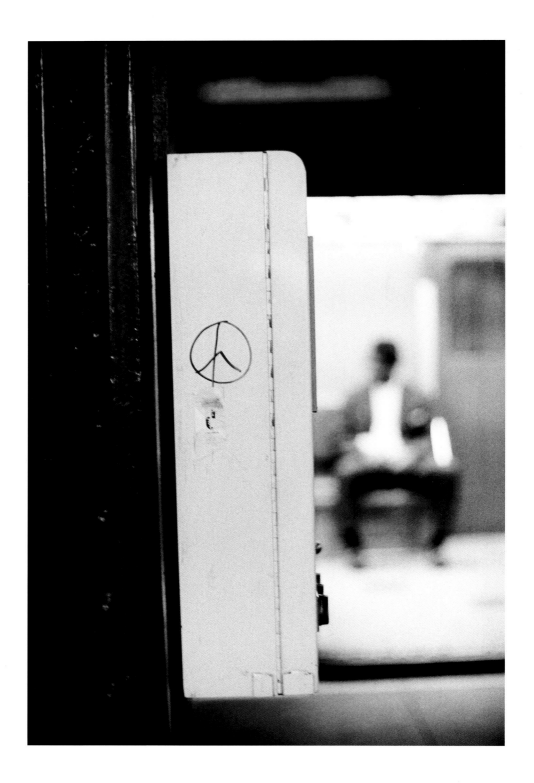

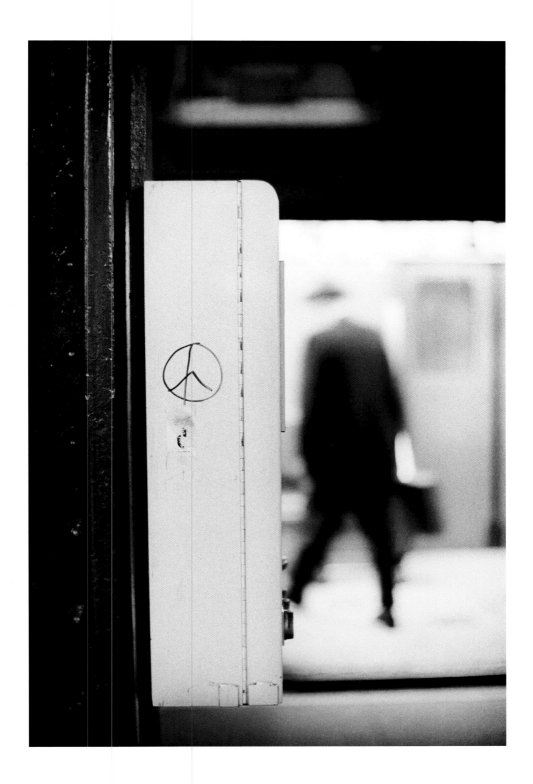

81

BIG A OCT

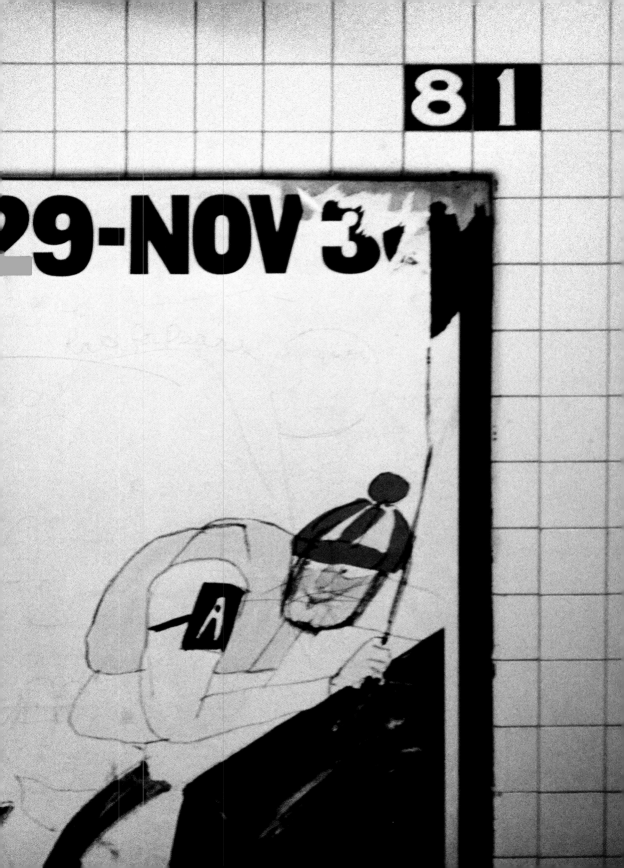

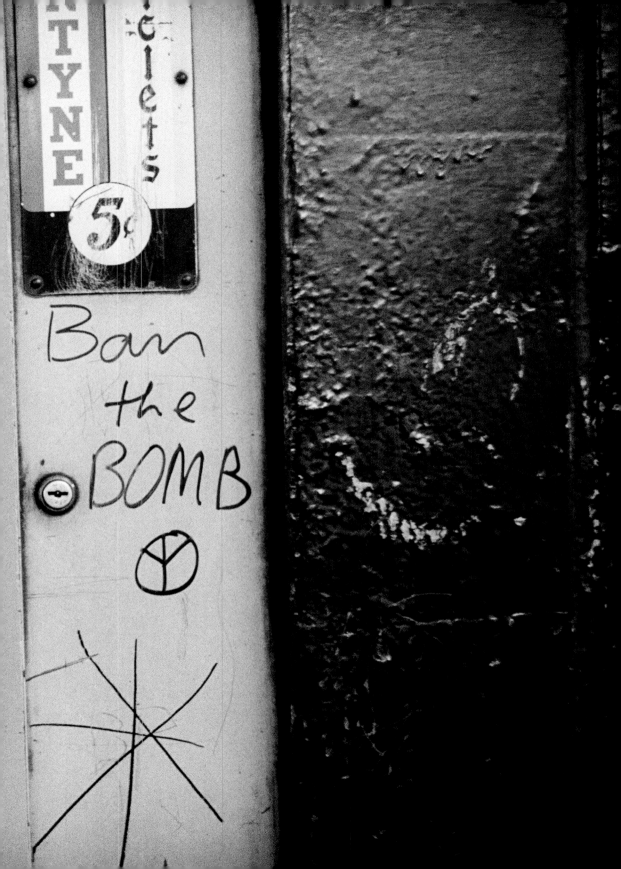

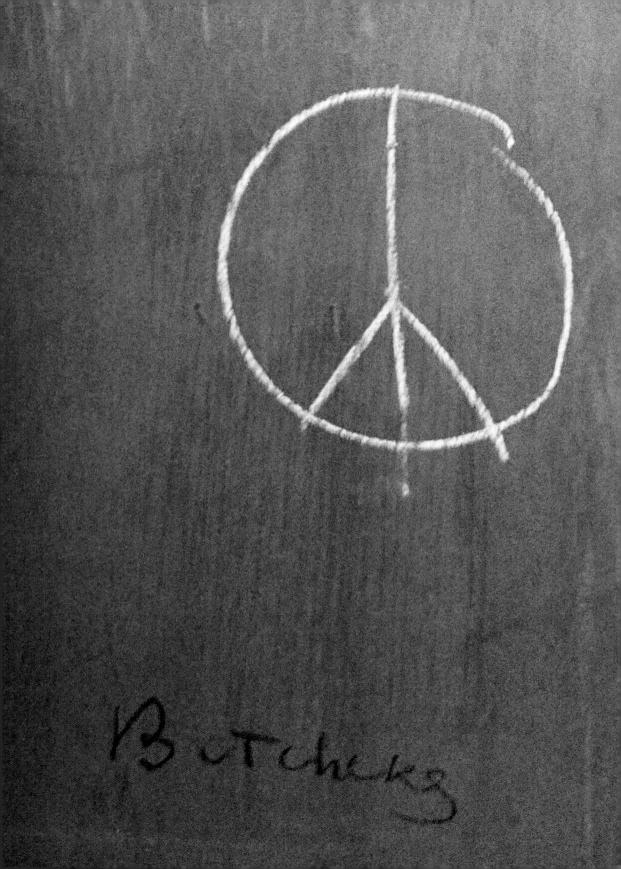

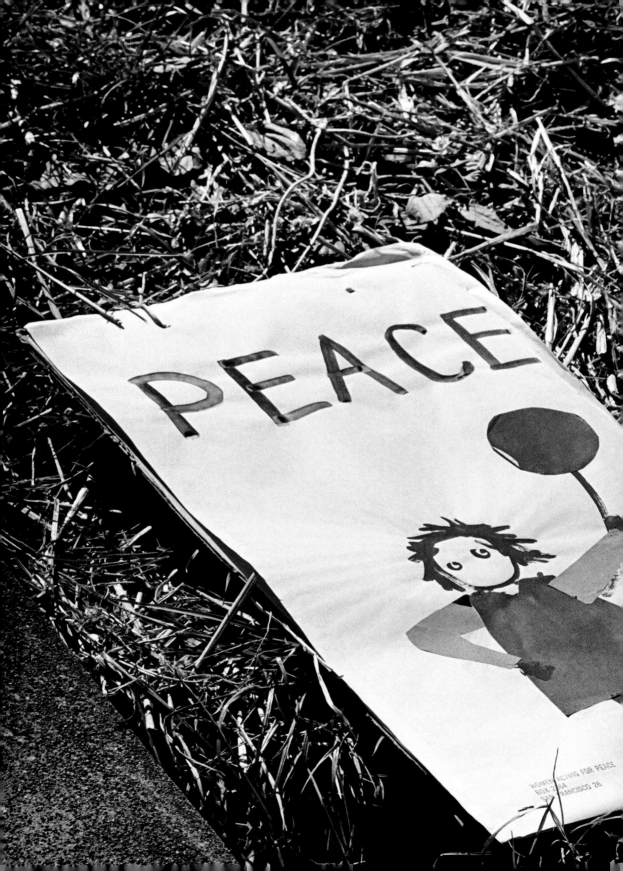

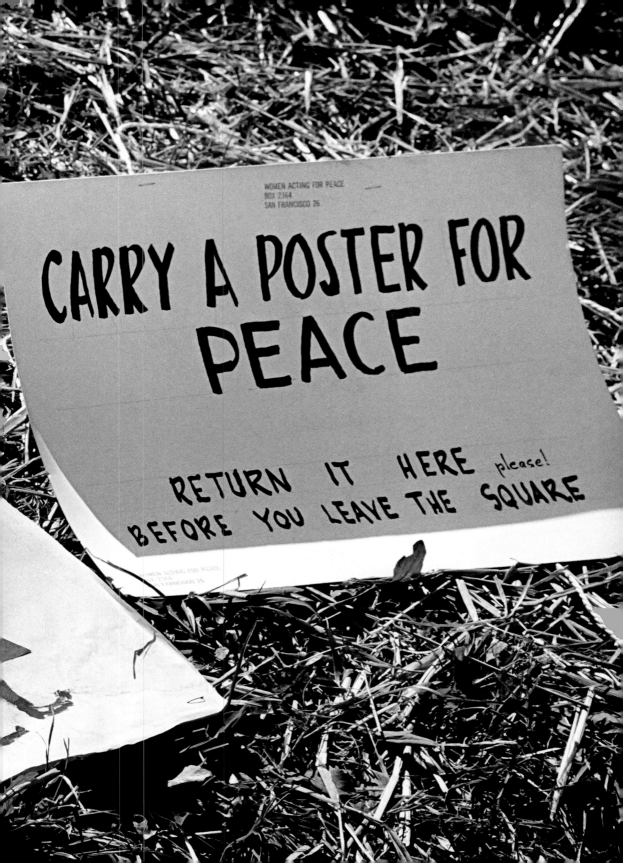

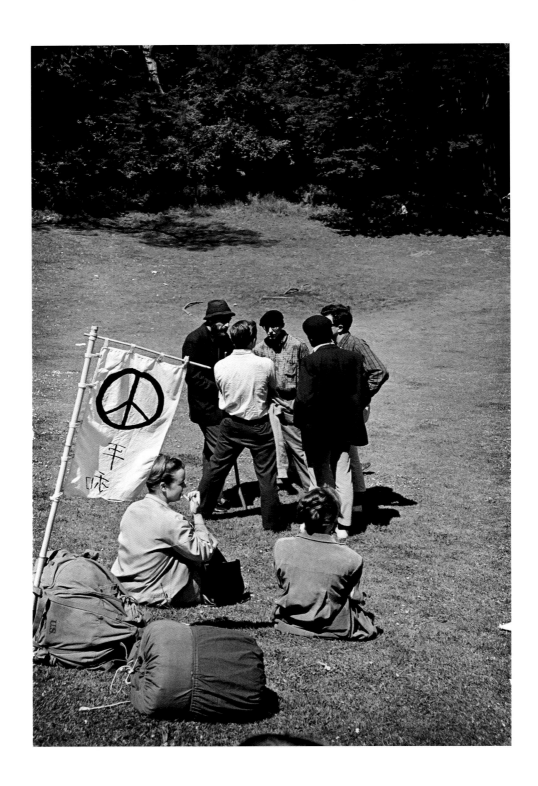

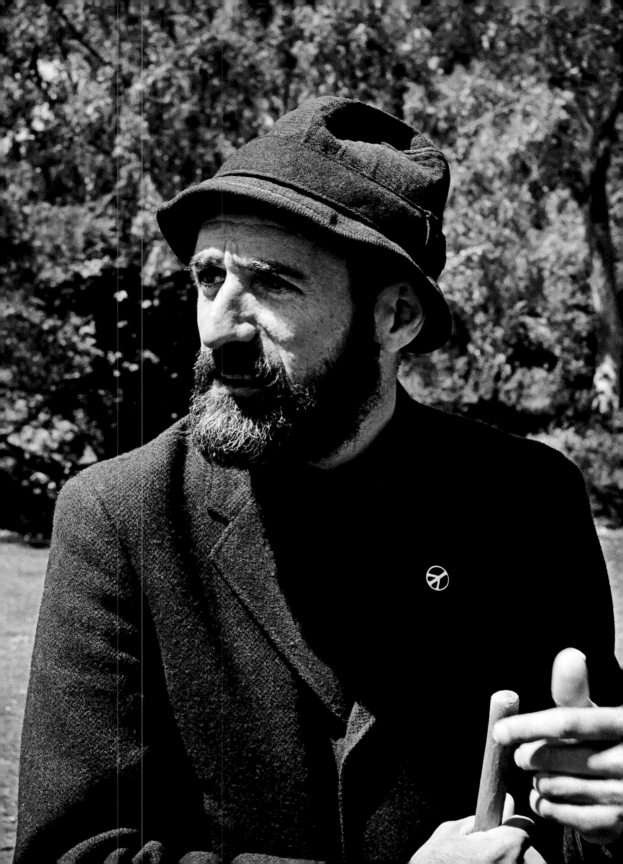

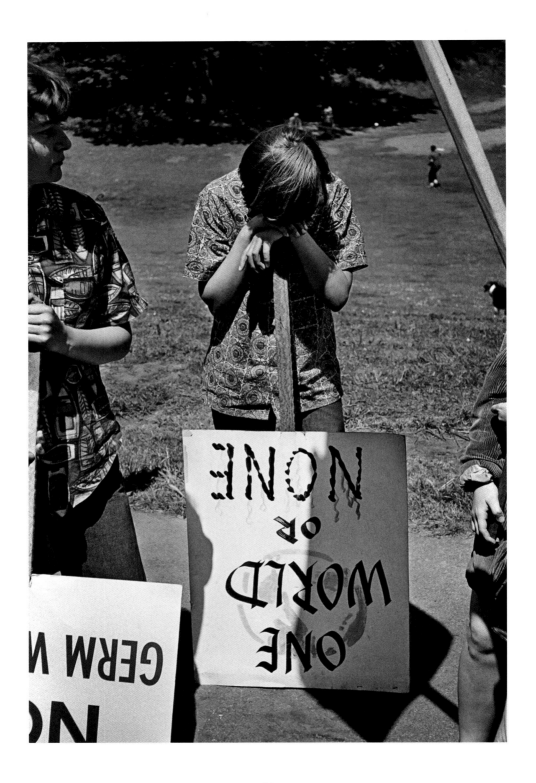

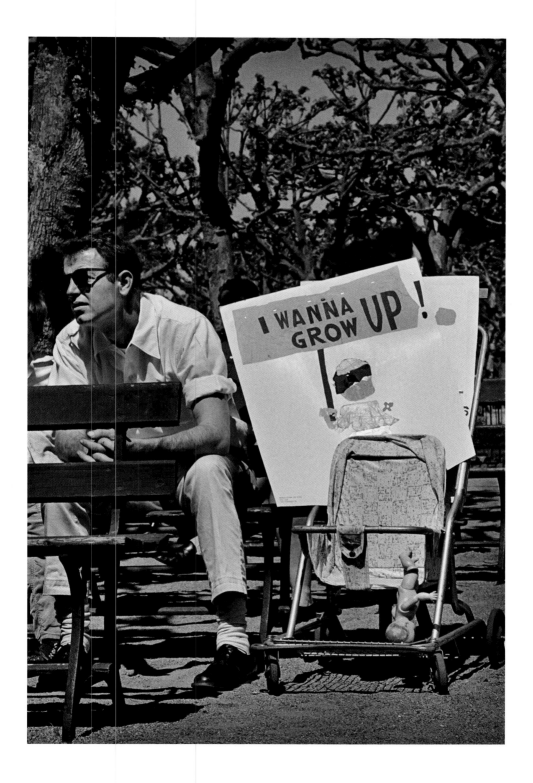

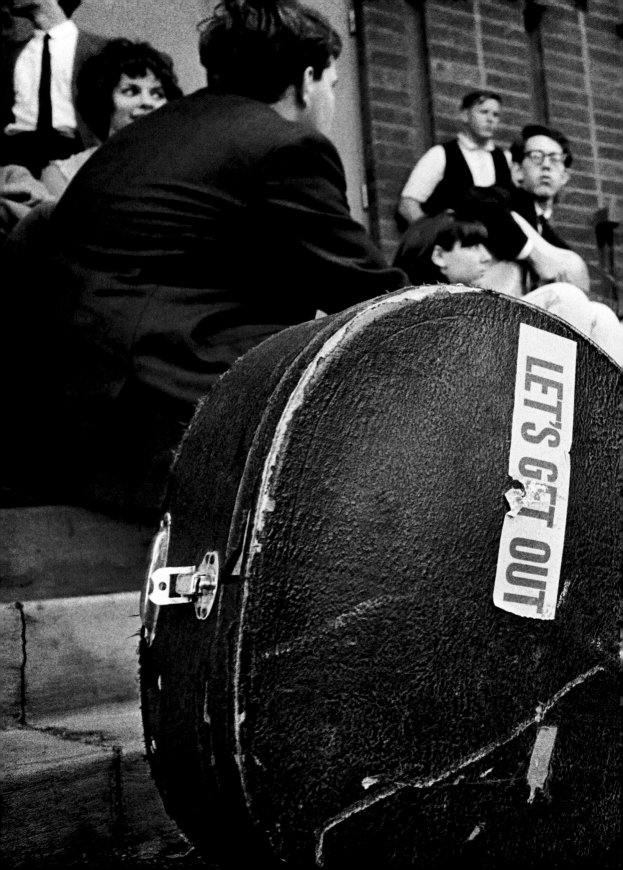

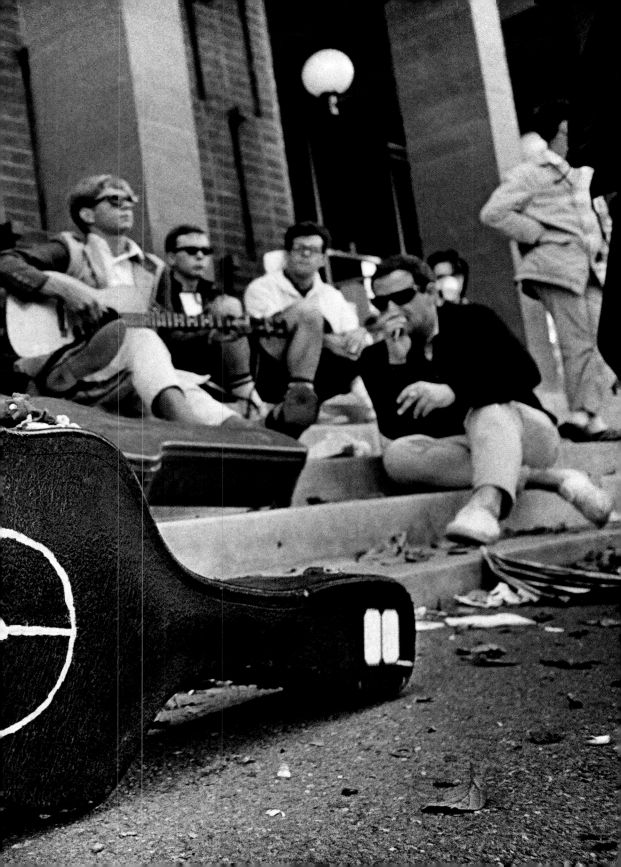

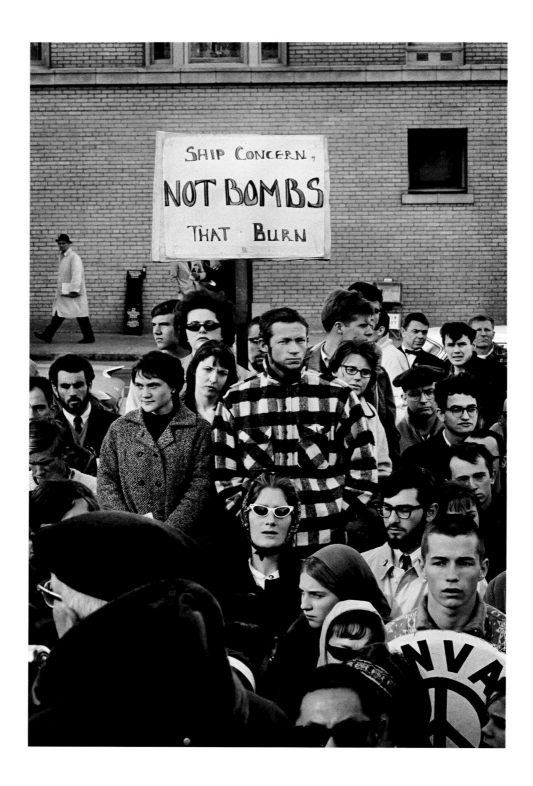

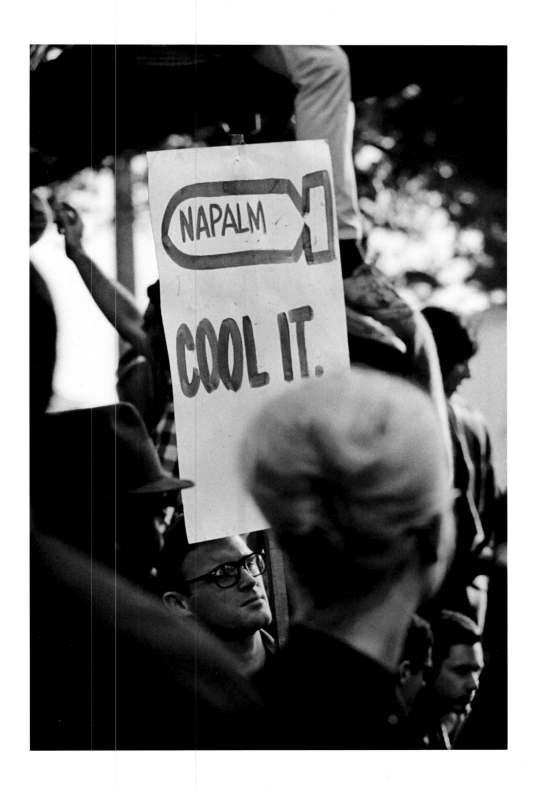

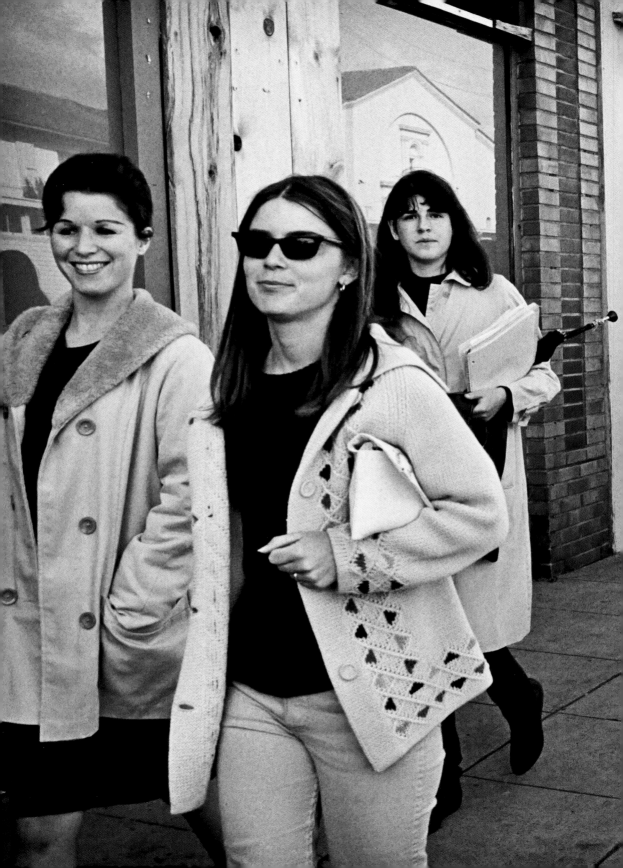

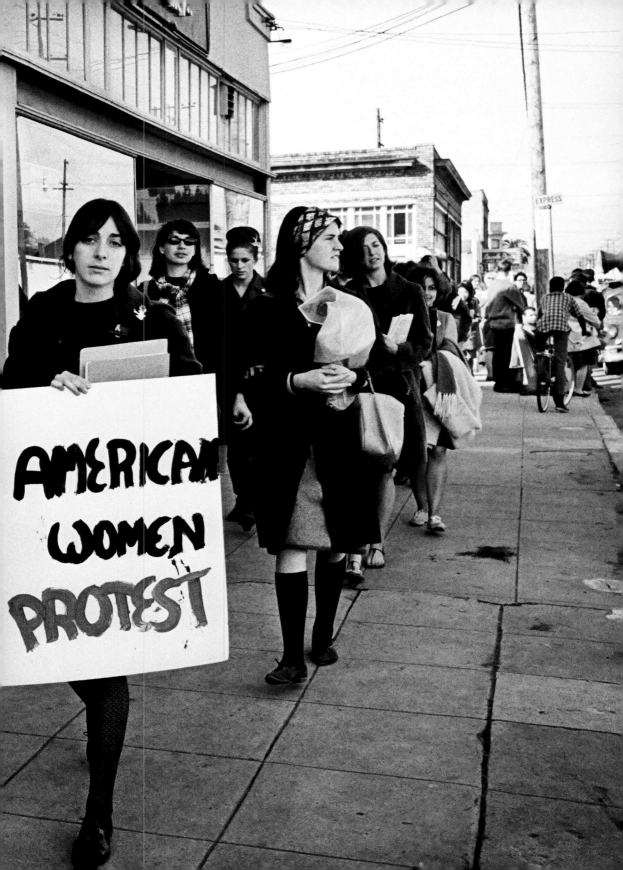

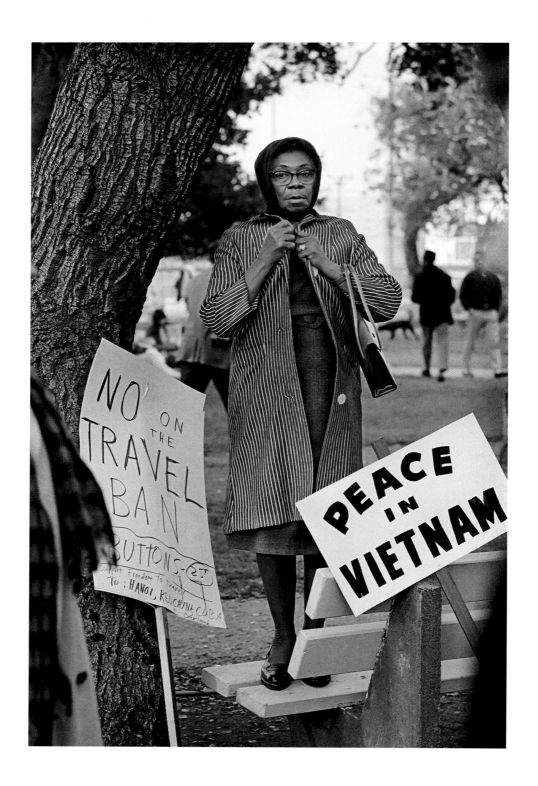

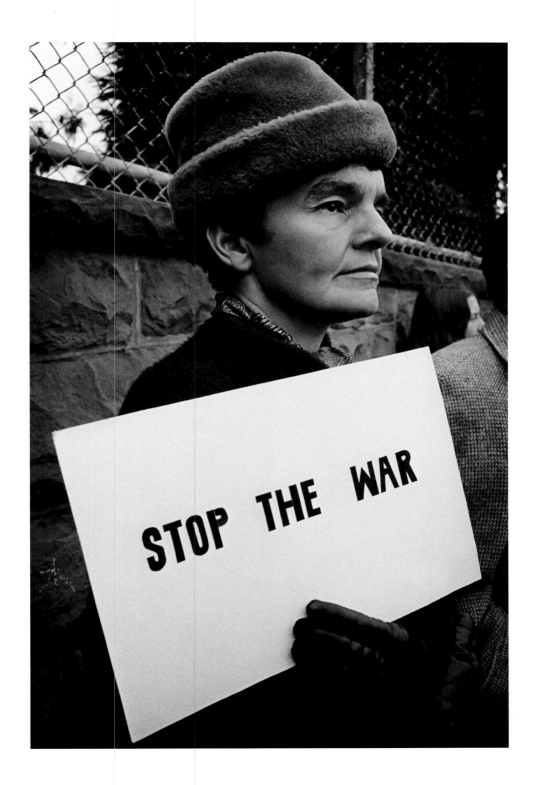

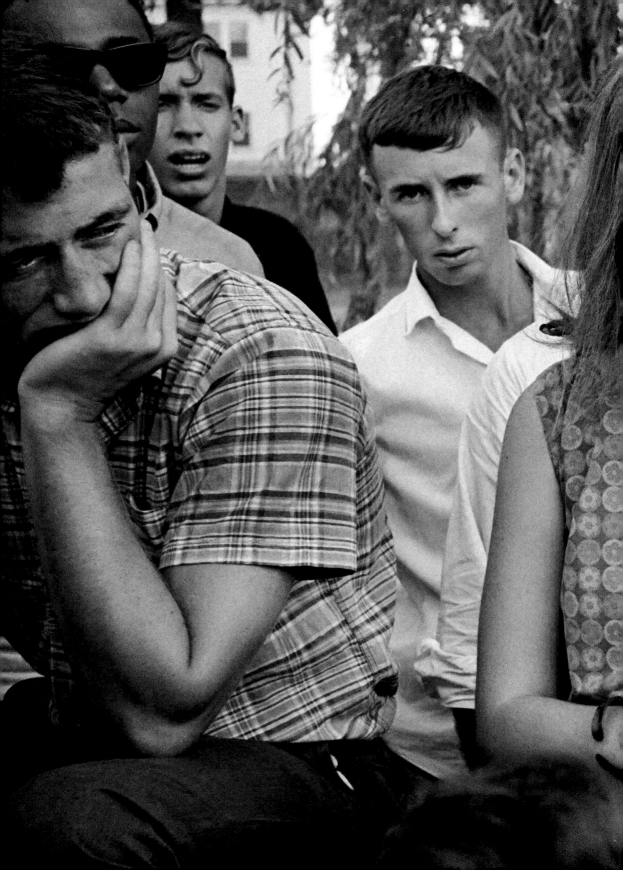

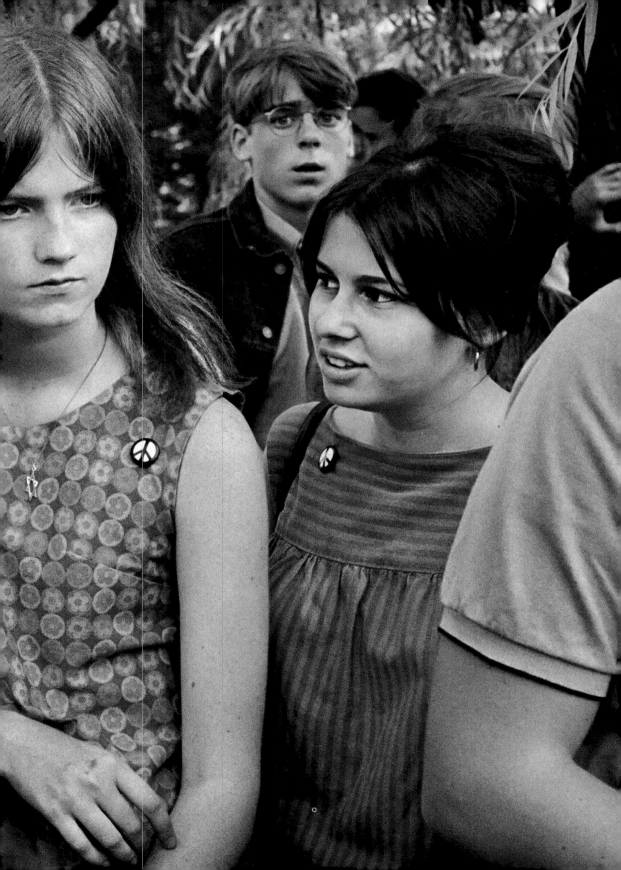

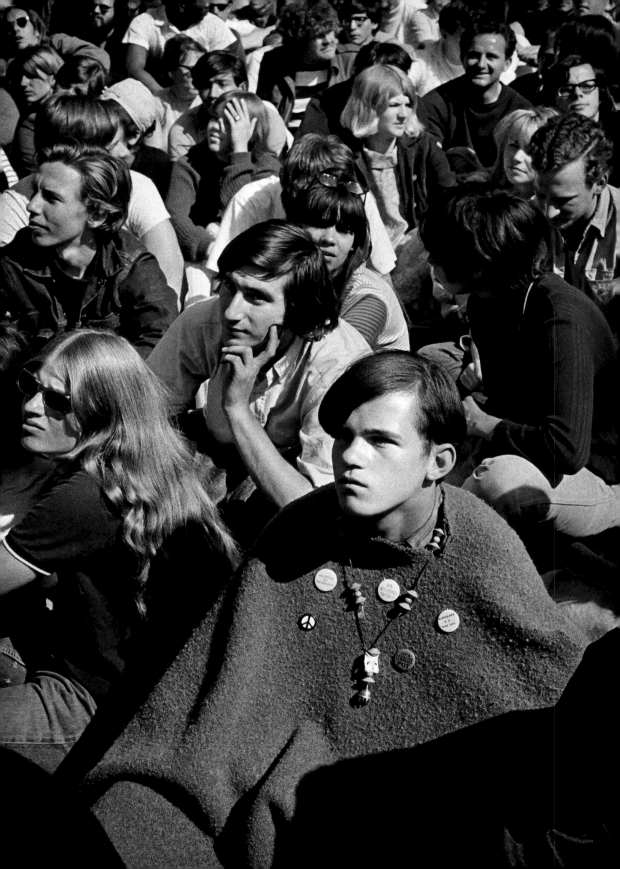

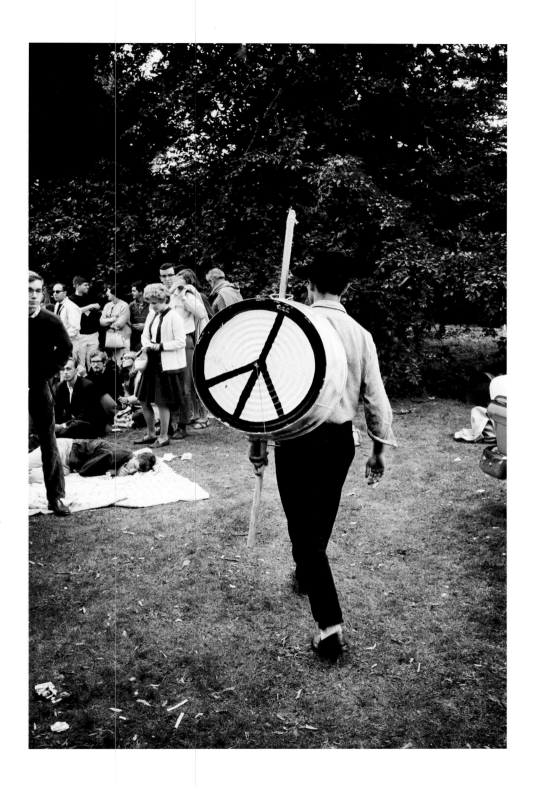

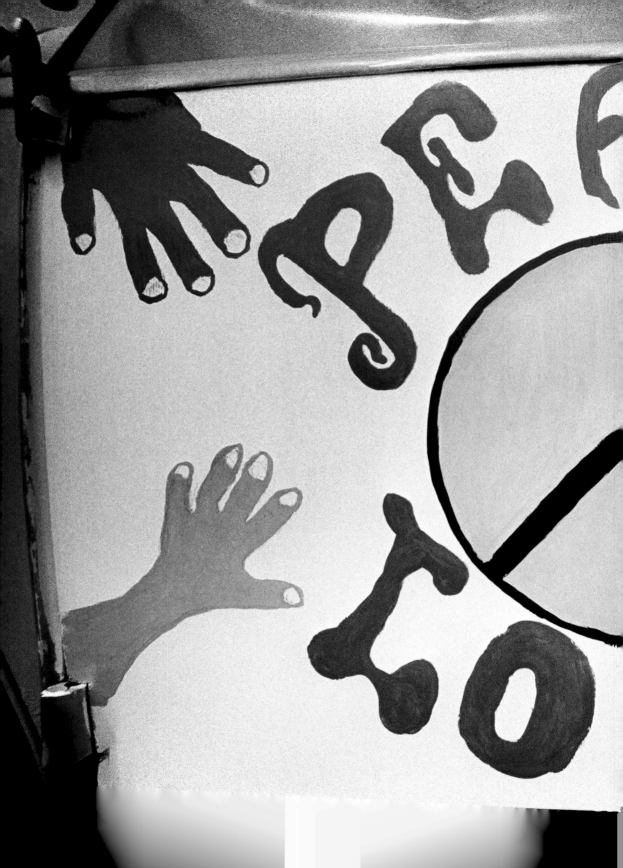

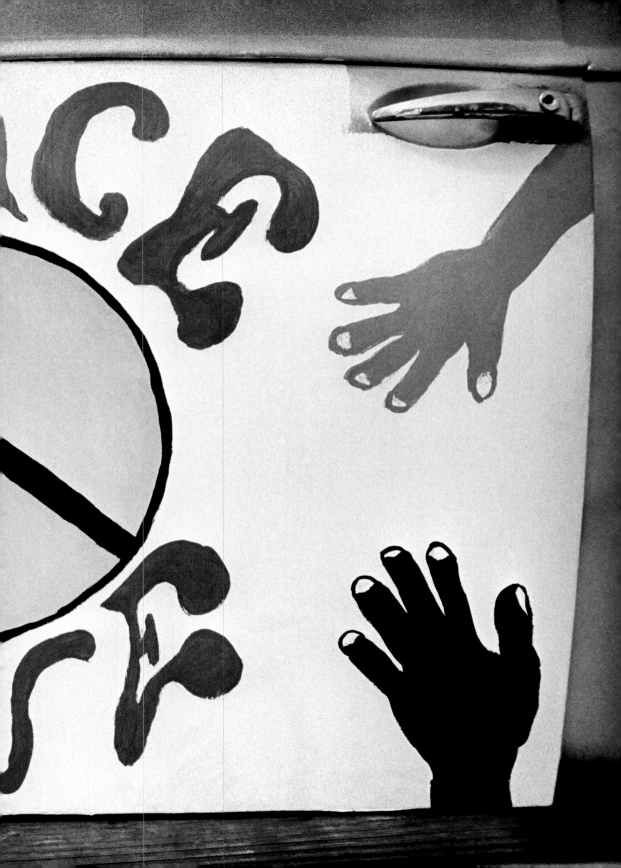

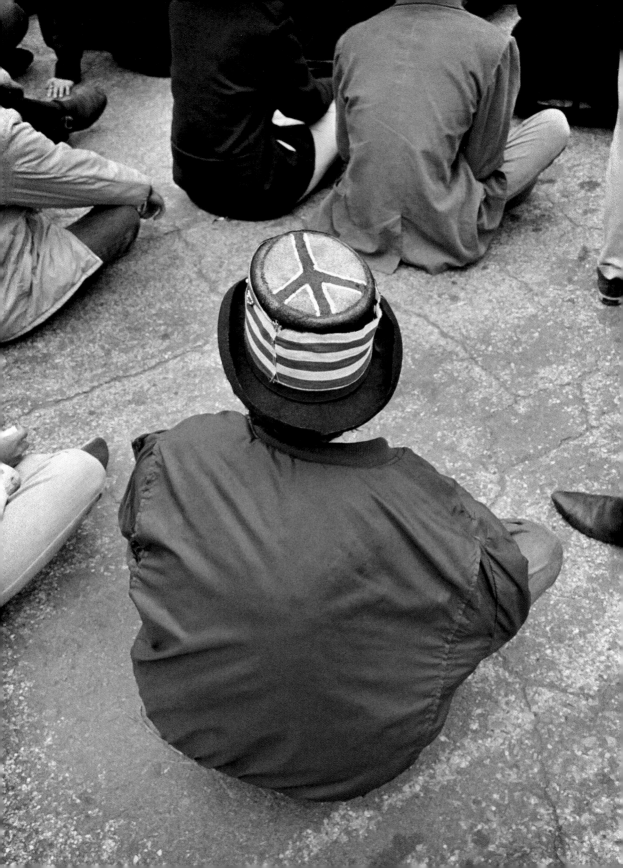

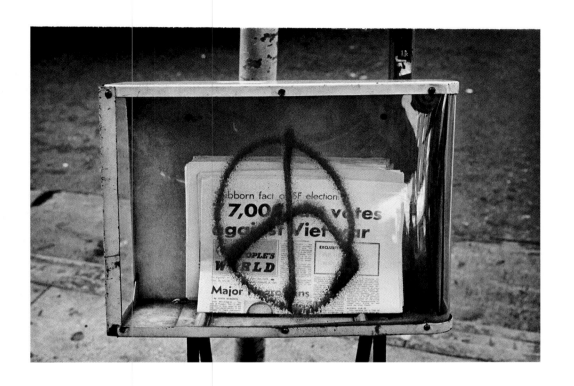

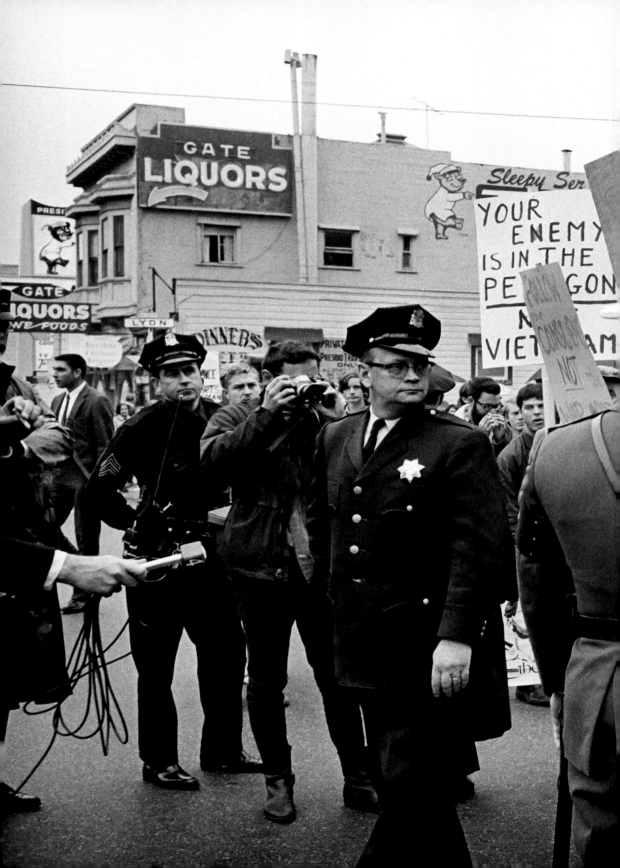

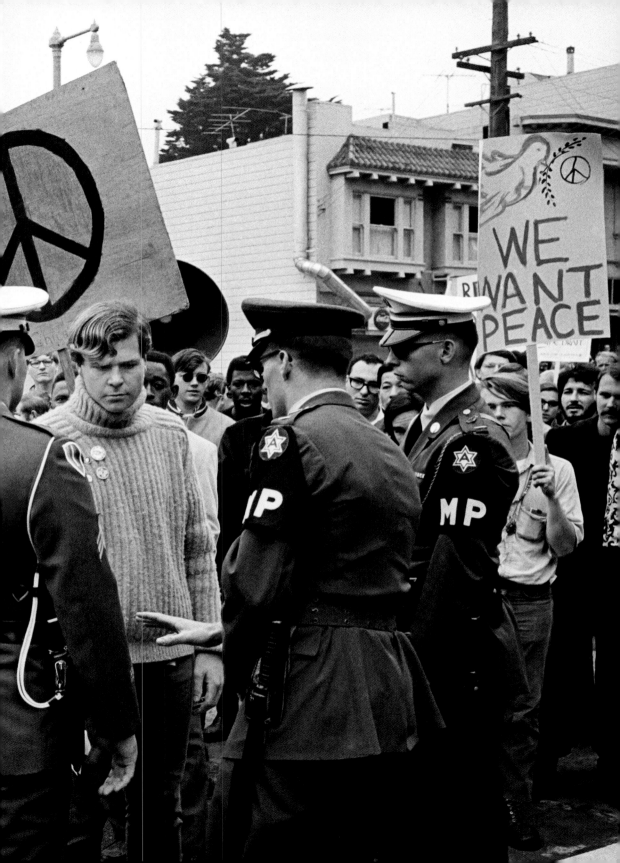

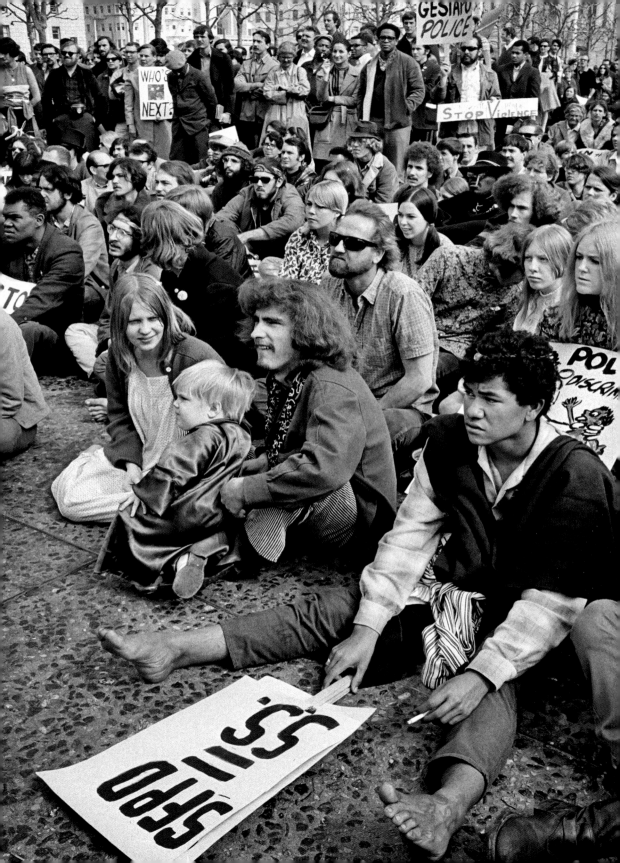

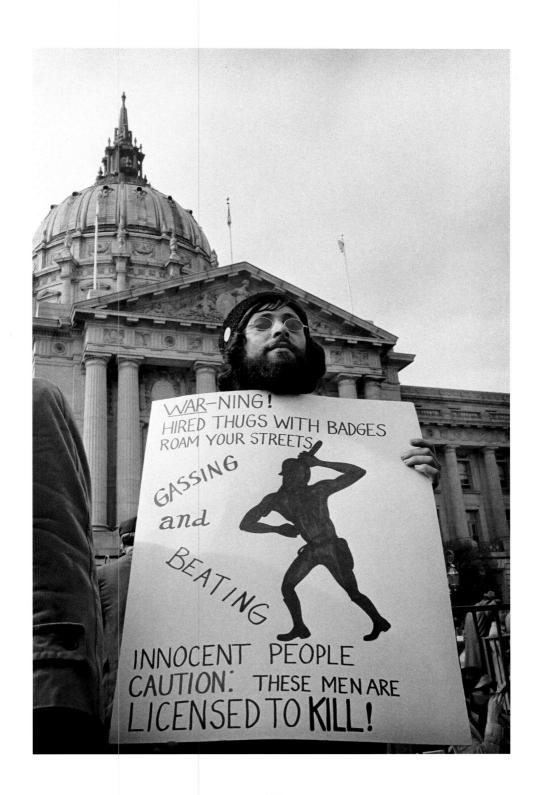

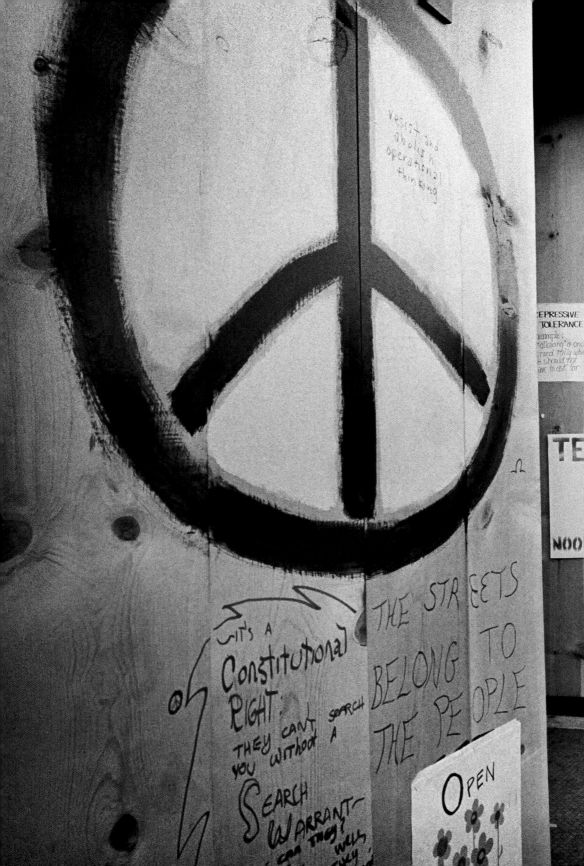

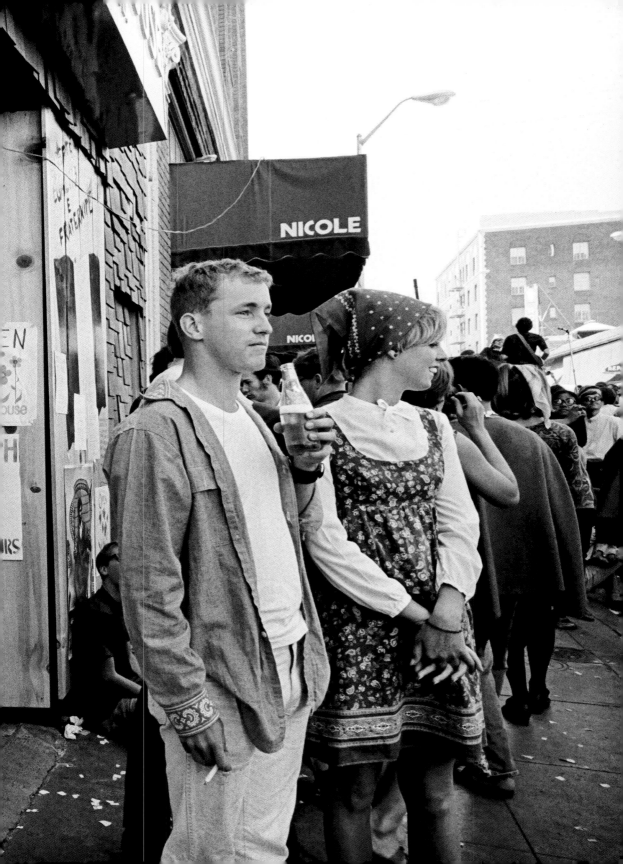

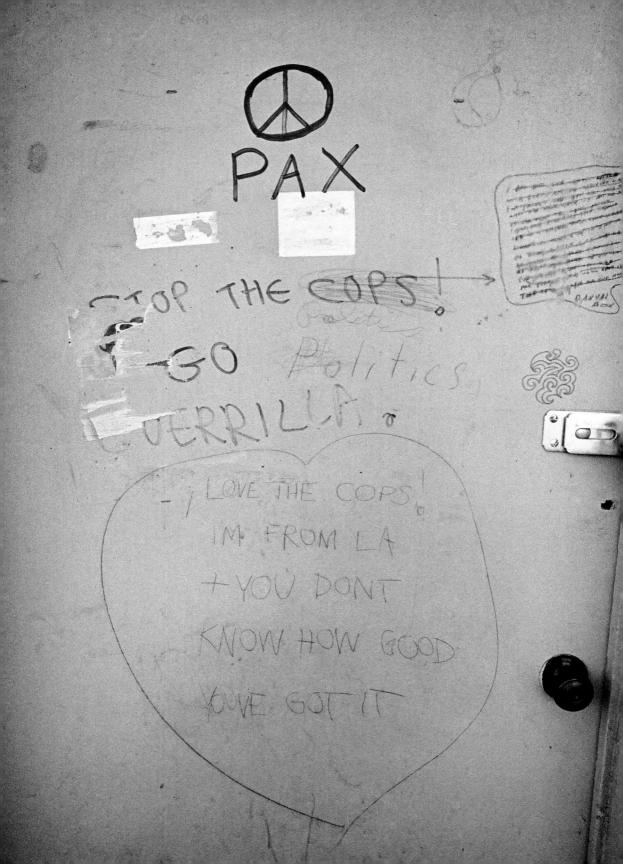

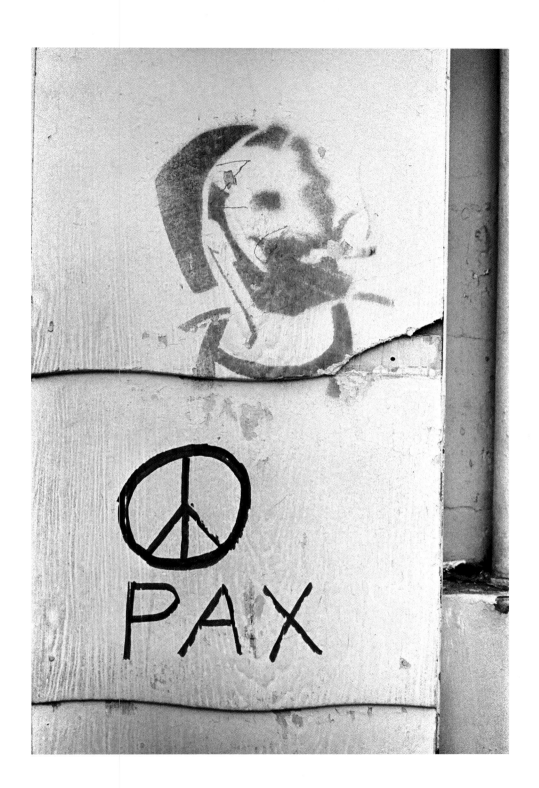

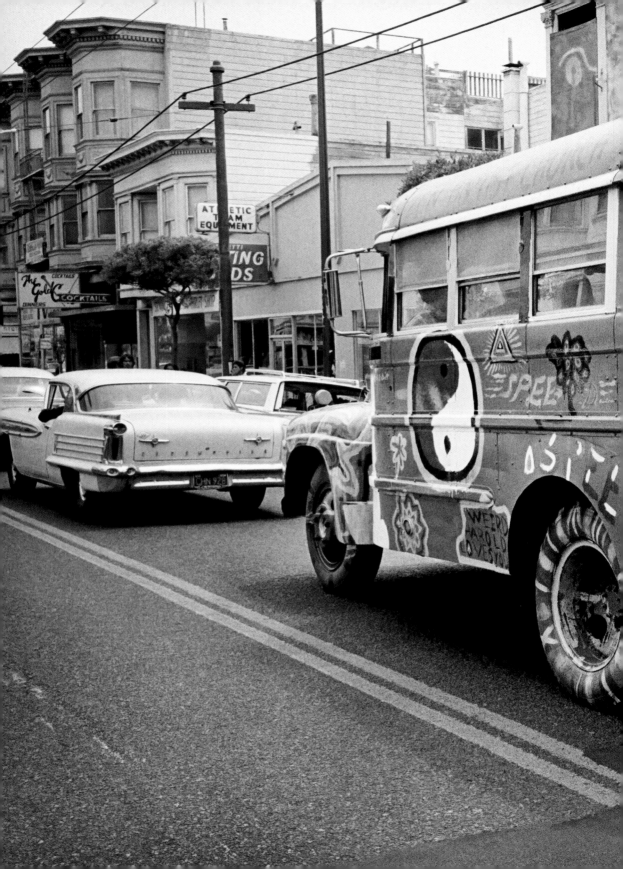

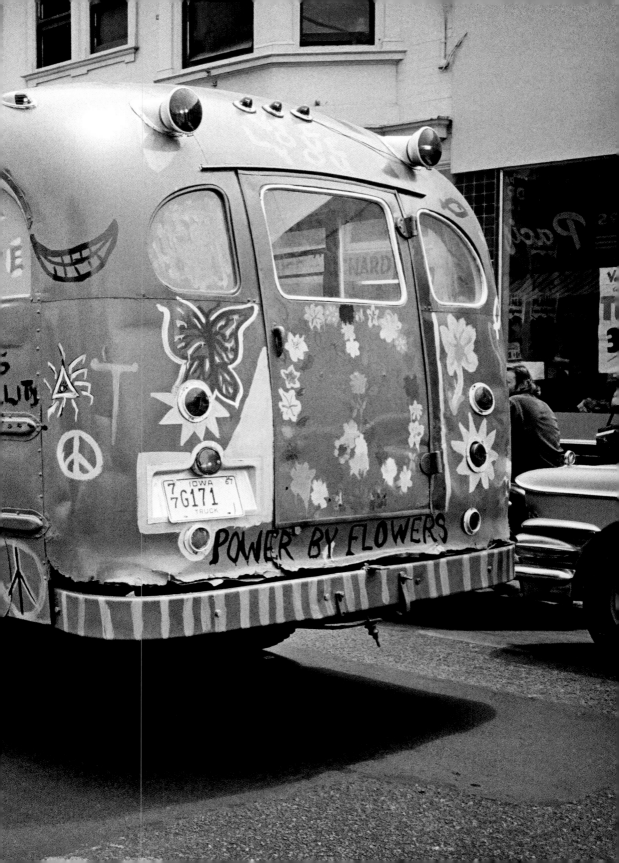

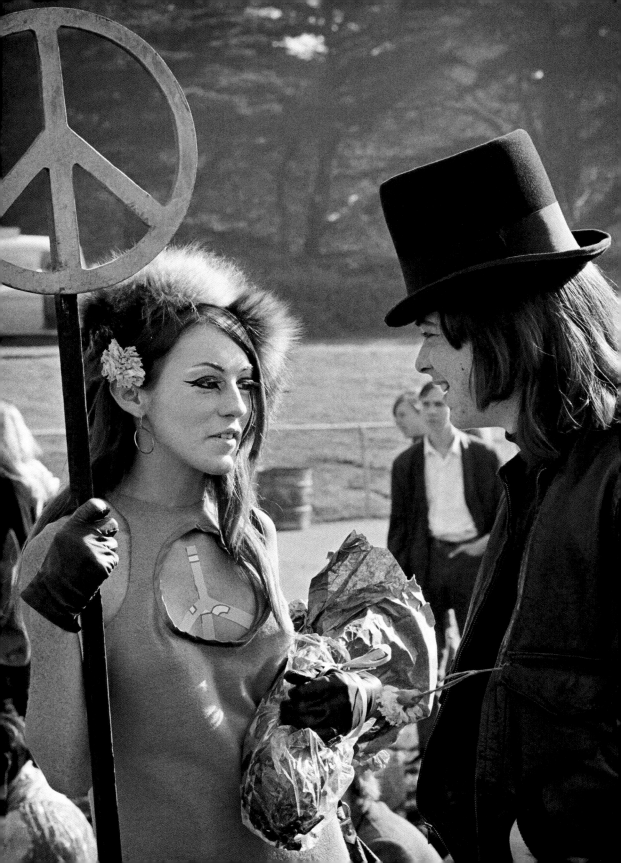

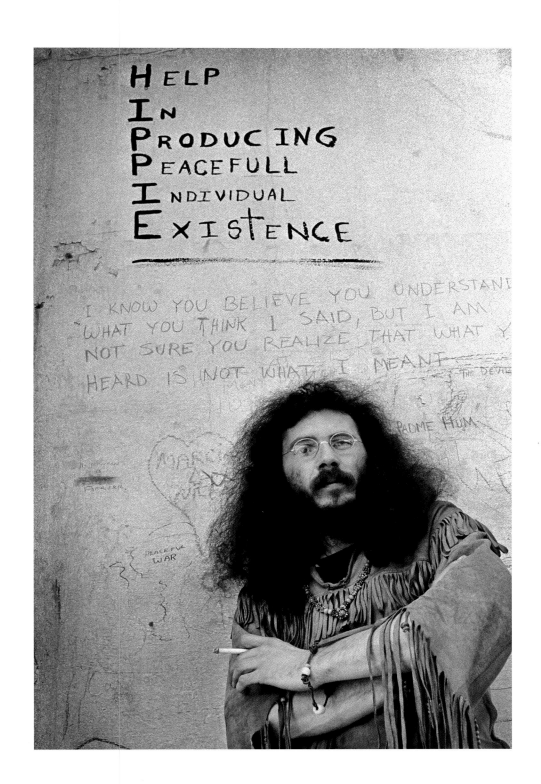

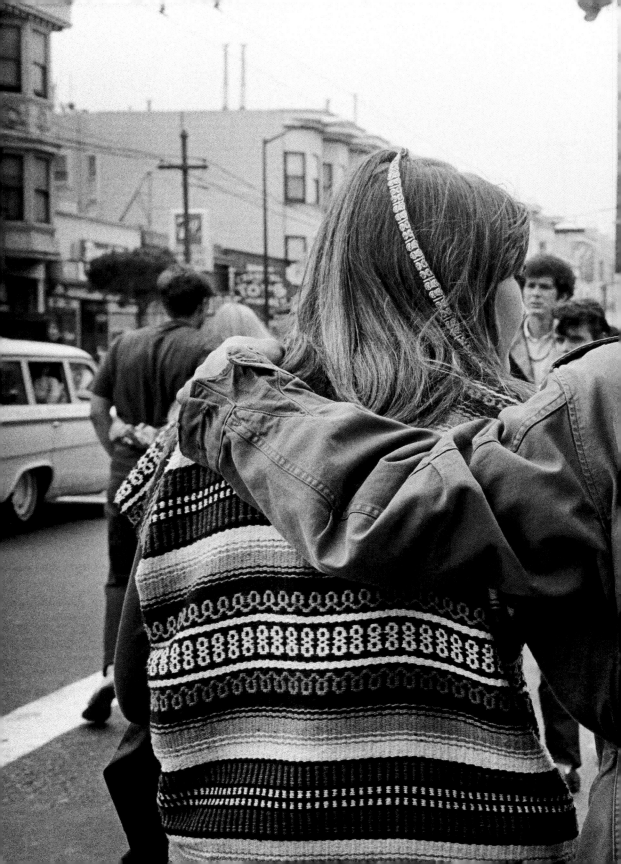

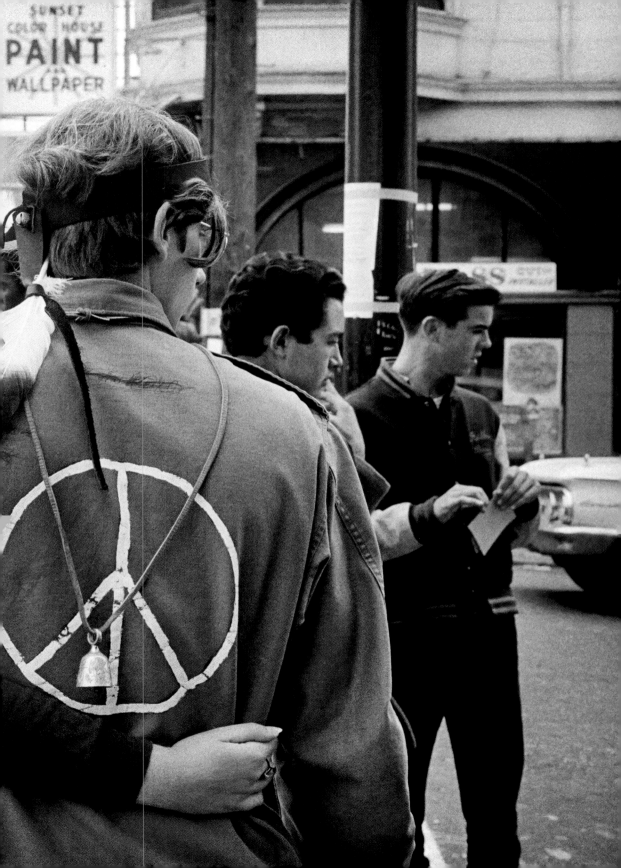

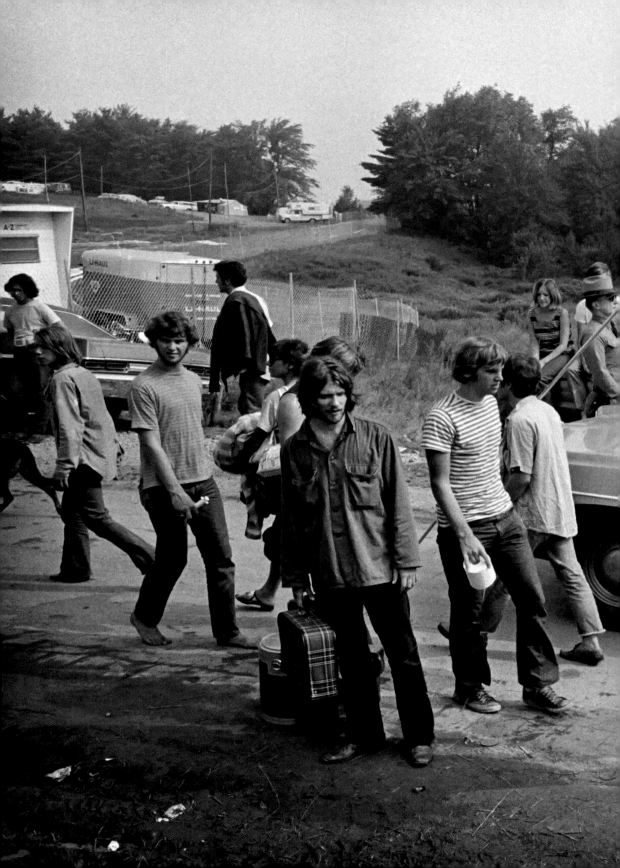

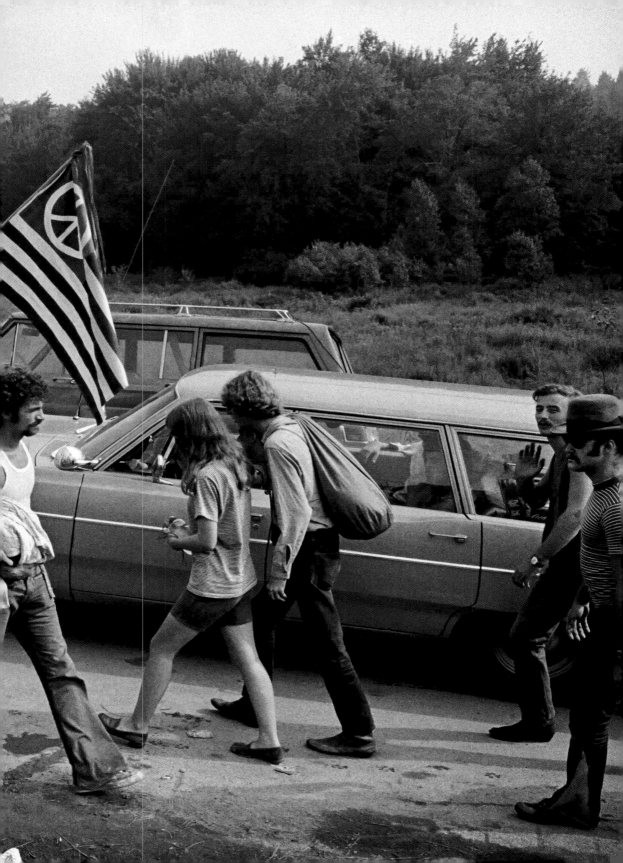

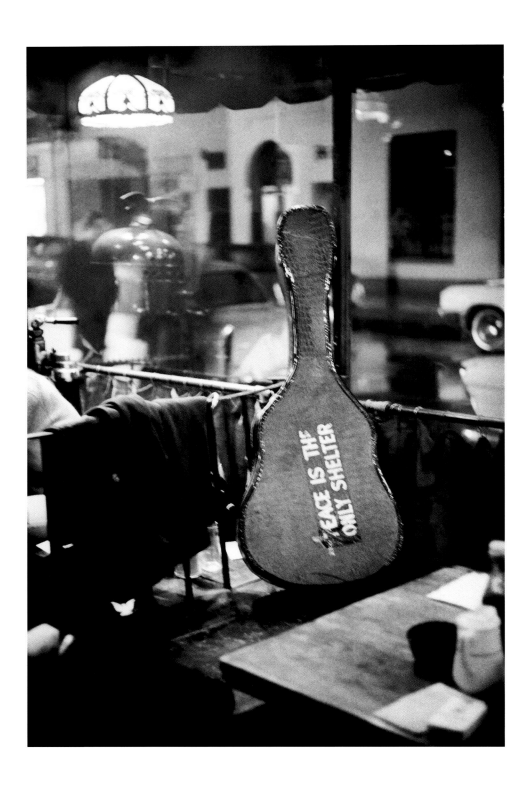

AFTERWORD

To my surprise I find, through the photos assembled in this book, that Jim Marshall had a fixation with the peace symbol. It is surprising to me because from my experience he was somewhat of a hawk. I can remember standing on my front porch one day, arguing with him about the virtues of George Bush (the first or second, I don't remember). I couldn't find many virtues, but then, even in his defense of Bush, neither could Jim.

Maybe he just enjoyed photographing inanimate objects because they couldn't talk back.

I chided him on everything, and somehow this pacifist folksinger found common ground with a gun-toting loose cannon like him. Throughout his triumphs and struggles, Jim remained a faithful friend over the years. He also produced some of the finest photographs on record of my family and myself.

Whatever was behind his urge to photograph peace symbols does not really matter. The images as seen in this book are as artful and powerful as his acclaimed photos of stars, musicians, and festivals for which he is known.

Peace be with you, Jim.

JOAN BAEZ

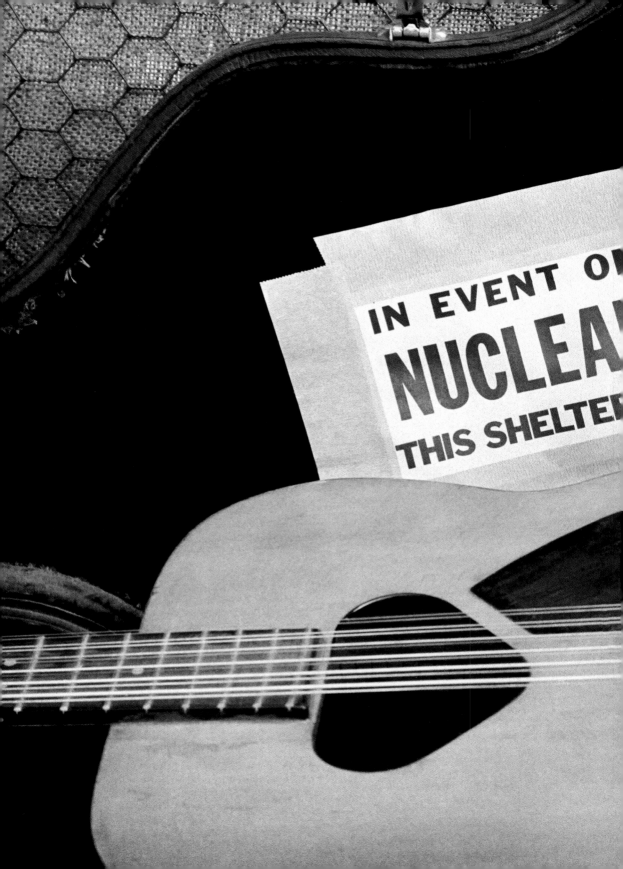

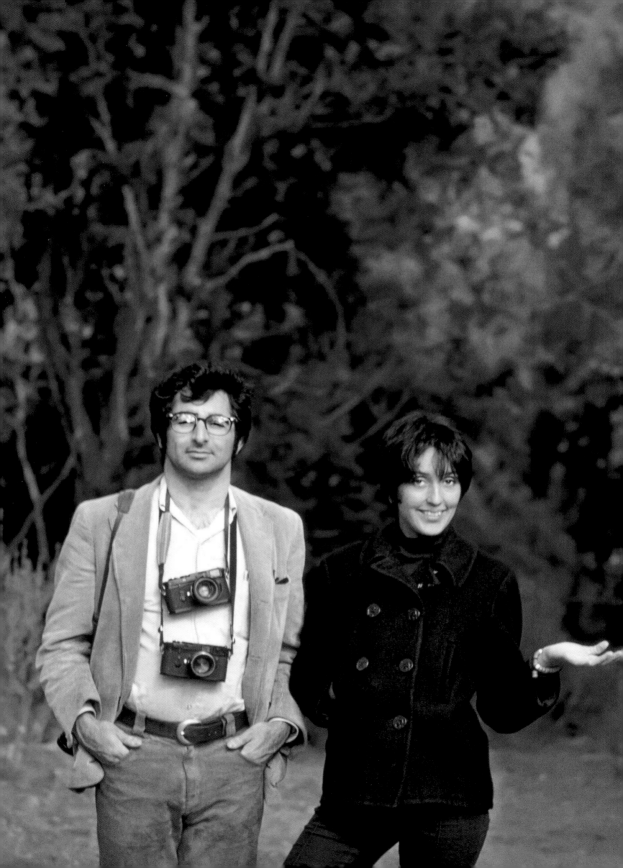

ACKNOWLEDGEMENTS

Jim Marshall loved music and musicians; his first love was jazz but his rock 'n' roll pictures are some of the most recognizable images ever taken, they define an era, a genre and a lifestyle. Among the many things Jim hated, really hated, was being called a rock photographer. "Ansel Adams was a rock photographer" he would shout, "I'm a photographer!" At the same time, Jim was uncomfortable with showing his non-music photography to a wider audience. His observational street photography in New York, San Francisco and Los Angeles, and his photo essays for *Life* and *Look* magazines are superb and the photos seen here show that his work is more relevant than ever.

Putting together the idea of Peace and Jim Marshall may seem like an unbelievable paring to those who know the stories about Jim's "crazy" life. As Jim said himself, "I've always loved cars, guns and cameras. Cars and guns have gotten me in trouble, cameras haven't." Jim always carried a knife or gun with his camera equipment. It would be fair to say that he was armed and dangerous. He bullied and pissed people off to get the pictures he wanted, but for Jim, it was worth it. He was usually forgiven, because everyone knew that Jim Marshall was a genius with a camera and would take the best picture. Beneath the aggressive persona, he was an artist who *had* to get that photo, no matter what. Jim had a curious eye and would never let the perfect moment elude him. As he liked to say "no one ever complained about a picture I took of them." I can imagine him kicking someone out of the way to take a photo of a peace symbol!

Despite his chaotic lifestyle, Jim kept detailed index cards listing the subject, date, location and the film number for everything he shot. One card just had the peace symbol along with the numbers of the corresponding proof sheets and negatives. When I looked through these proof sheets I was amazed at what Jim captured.

Jim would absolutely hate the idea of this book, but he went out of his way to make it happen. Year after year he shot hundreds of peace symbols, he was always looking for peace it would seem, not only for him but also for the rest of the world. Thank you, Jim!

Dave Brolan, as always, is invaluable with his friendship and insights into Jim Marshall. Thank you for helping me put thoughts into words! Thank you to Joan Baez for sharing her thoughts about Jim and this book. And to Nancy Lutzow for making this happen. Thank you Shepard Fairey for not only your important contribution to the book but also for your continued friendship and support for Jim Marshall's legacy. Dan Flores always comes through and makes sure whatever needs to happen, happens. Thank you! Peter Doggett has supplied an incredible context and history for this book. I so appreciate your contribution. Thank you Ben Kautt and Jay Blakesberg for always protecting Jim Marshall's images. It is such a pleasure working with Tony Nourmand and the team at Reel Art Press. Tony, you have curious and similar aesthetics to me that it makes it a joy to work with you. I look forward to the many more books we do together. Ali, as Tony says, "You do the work of ten men." I feel ya, girl! Bonita Passarelli is the glue that holds me together. Thank you for your love and support, always!

AMELIA DAVIS

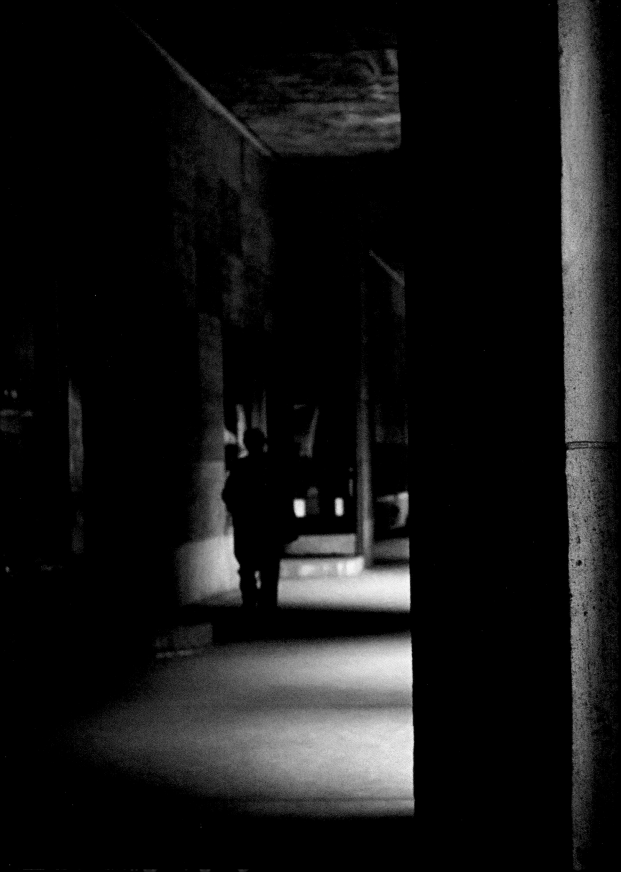

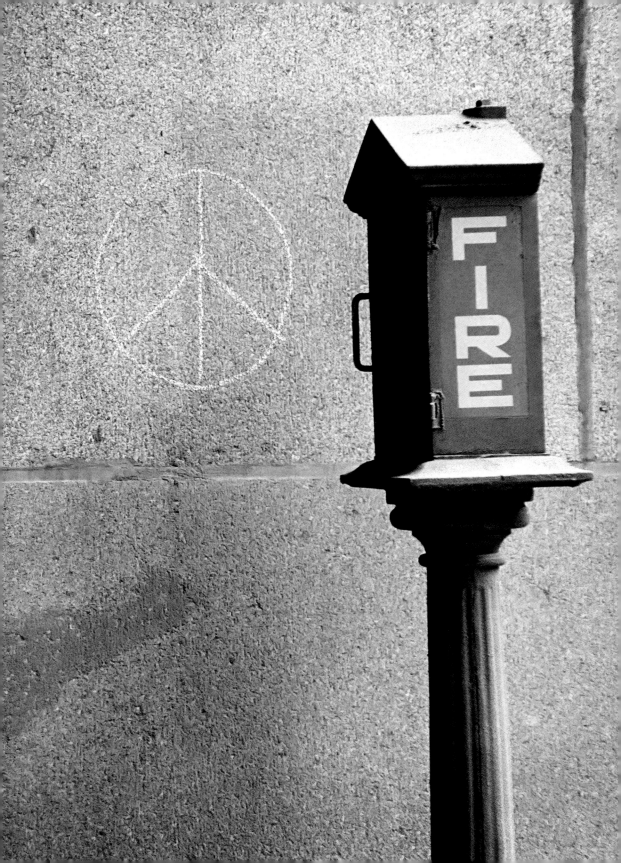

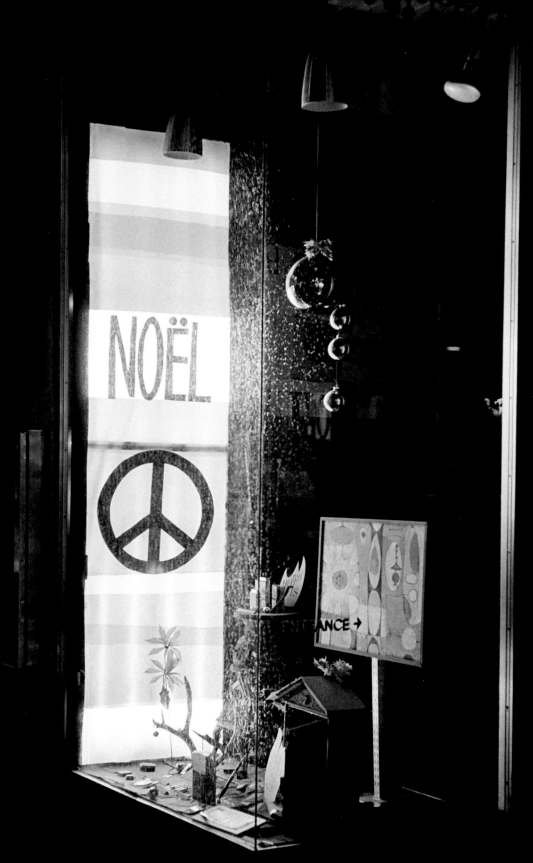

CAPTIONS

Text Editor: Alison Elangasinghe
Assistant Editor: Rory Bruton

First published 2017 by Reel Art Press, an imprint of Rare Art Press Ltd, London, UK
www.reelartpress.com

First Edition
10 9 8 7 6 5 4 3 2 1

ISBN: 978-1-909526-48-8

Pre-Press by HR Digital Solutions

This book is printed on paper Condat matt Périgord, ECF, acid free and age resistant.
The Lecta Group uses only celluloses from certified or well managed forests and
plantations.

Printed: Graphius, Gent

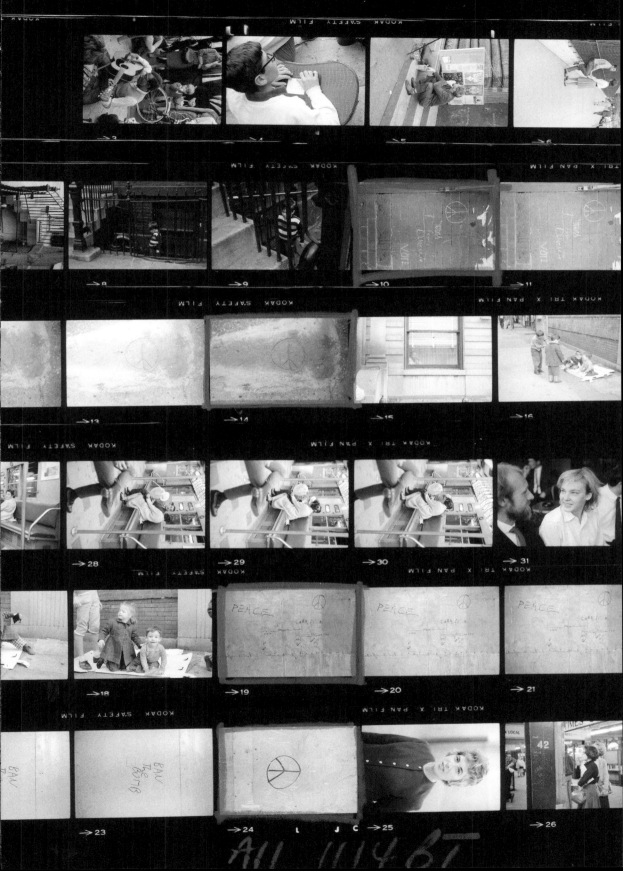

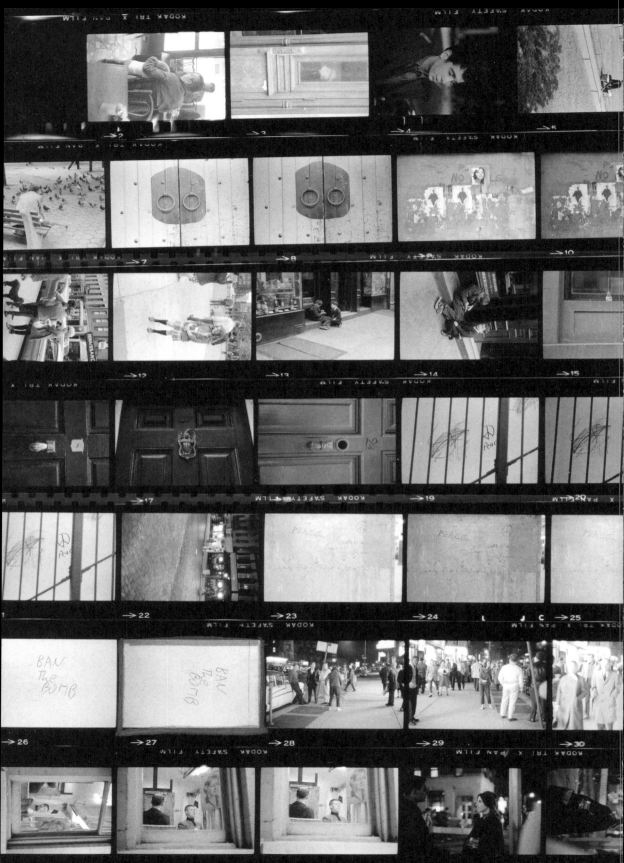